A BRIEF HISTORY OF
COOKE CITY

A BRIEF HISTORY OF
COOKE CITY

KELLY SUZANNE HARTMAN

with contributions by Cooke City Montana Museum

THE
History
PRESS

Published by The History Press
Charleston, SC
www.historypress.net

Front cover: (*top*) Tourists on horseback in front of the Curl House. *Yellowstone Gateway Museum of Park County, 2006.044.5103*; (*bottom*) Road into Cooke. *Oil painting by Kelly Hartman.*

Back cover: Miners at the Daisy mine. *Cooke City Montana Museum.*

First published 2019

Manufactured in the United States

ISBN 9781467142892

Library of Congress Control Number: 2019935344

Cooke Mont. Nov 16, 1925

My dear friend Isobel!
I have been very pleasantly surprised of your longing and kind Letter which I received oct. 30th a question if I am still at Cooke—I surely have to stay at Cooke my Husband has done here so much work on his Claims that we can't leave Cooke anymore although he has not strike the ore yet. I am very lonesome being so far remote of all civilization but I have to stay as long as he is able to work he might strike it still, in our place is always gold and Silver assays of course in a small quantity as yet.
I not wonder to you that you are longing to be back in Cooke. It was that time a Virgin Place where you were born and there was more People at Cooke at that time than it is now…

I remain yours Truly Anastazie Zucker

❧

To Anastazie Zucker, I remain yours truly

CONTENTS

PREFACE

In 1990, my parents bought a cabin in Silver Gate, Montana. Although I was born in Jackson, I essentially became a valley native at the age of one. My sister and I spent our days roaming through Yellowstone National Park, the Beartooths and the Custer Gallatin National Forest with our parents, who were and still are naturalist-photographers. For school, we attended the one-room schoolhouse in Cooke City, where the whole town was present for all of our greatest achievements, including school plays, presentations and, of course, eighth-grade graduation. Then came the shift to high school, which I attended in Gardiner, Montana, an hour and a half away from home through the park. Life continued, and I ended up at Northwest Community College in Powell, Wyoming, where I spent two years getting my associate's degree in art before making a bigger move to Western Oregon University in Monmouth, Oregon, where I received my bachelor of fine art in painting. And then, I came full circle back home armed with an art degree and no sense of what I really wanted to do with my life.

Concurrently, longtime Cooke City resident and historian Dee Smith suddenly passed away. She had been tirelessly working on creating a museum to house artifacts preserved by, among others, Margaret Reeb, whose family had arrived in the pioneering days of Cooke. As life in a small town would have it, my sister, Cassie, had worked on the grant that provided the funding for the building and exhibits, and she quickly roped me into a job. The whole operation became a sister affair when I began working with Dee's sister Florence to carry out the work that both Dee and Cassie had started.

Within a year, the Cooke City Montana Museum had opened to the public (in 2014), and I had found my career and my heritage. While I had grown up here, I found that I had known little about the people who had come before. One of my favorite moments was uncovering the story of Anastazie Zucker, which is presented in part eight of this book. I was lucky enough to get to share her life story with over five hundred people at the historic Ellen Theater in Bozeman, Montana.

Cooke City has always been a town in waiting—waiting for transportation, for a railroad, for the big strike, for visitors to come, for a dream to be realized. While there is very little primary source information to be found about Cooke City, I found local newspapers to be extremely helpful in telling the town's history. They lend color to the text but should be taken as just that. The many quotes I used are a lens through which to see Cooke City the way that many contemporary readers dealing with the issues that plagued the area during the early part of the twentieth century would have seen it. I acknowledge the bias from which they were written and tried to find opposing points of view as often as I could to explain the full issue at hand. In many instances, the text found in newspapers offered snippets of life from the miners themselves reprinted for a bigger audience.

So, this is their story—the people who lived and died waiting for a railroad that never came. It is being told now so we may never give up hope that something better is coming our way.

ACKNOWLEDGEMENTS

I'd like to acknowledge those who have worked tirelessly to preserve the history of Cooke City: Margaret Reeb, who kept the spirit of the miner alive, and Dee Smith, who saw the Cooke City Montana Museum through. A big "thank you" to the Cooke City Community Council, who put faith in me to tell this story. Also, thanks to the Yellowstone Gateway Museum, the Heritage and Resource Center, the Mansfield Library and the Gallatin History Museum for opening their archives to me and to Kathy Kleppinger, granddaughter of miner Nick Tredennick, for the use of her family photographs. And, finally, to my family and friends who have supported me throughout this process—this is the land and the history we have inherited.

1

EARLY DISCOVERY OF GOLD ON THE CLARKS FORK

We Hope They May Be Successful

The curtain rose on Cooke City long before man came into the picture. Geological forces had created the mineral wealth stored in the mountains and the volcanic activity that destined Yellowstone National Park. Politics would determine much of the area's history, but the landscape itself created the politics. This was a borderless land that eventually found itself trapped in a tangle of maps. The first players appeared in 1870, when a party of four men—Adam "Horn" Miller, James Gourley, Ed Hibbard and Bart Henderson—made their way into the valley. This story would be told into legend in the late 1920s, when the era of these men had died away and the history was left in between the words of old-timers whose memories thrilled at the prospect of a young reporter with eager ears and a willing pen.

Within three years of the initial discovery of gold, local newspapers were reporting an exodus of miners from Bozeman, Montana (130 miles away and the largest local hub of civilization). All were looking to get in on the action. Recent gold strikes throughout Montana Territory had created a sense of heightened excitement at the prospect of being in on the next big find. It was noted in Bozeman's *Avant Courier* that "very favorable reports" had been received from the Clarks Fork mines, and those going would be making a "thorough exploration of the country, both for quartz and placer mines." The findings in that general vicinity had become known as the "Clarks Fork

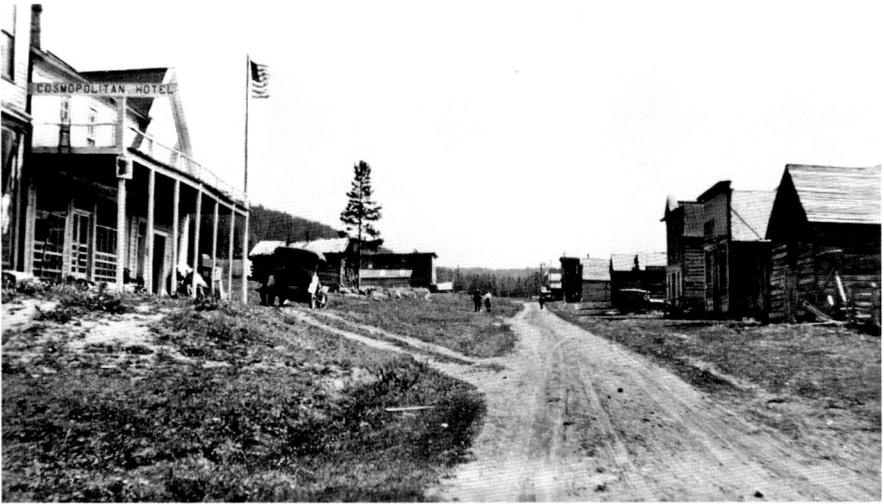

Cooke City looking east shortly after the arrival of the automobile to the area; Cosmopolitan Hotel on the left. *Yellowstone Gateway Museum of Park County, 2006.045.0092.*

mines" due to their being in the area of the Clarks Fork River, a 150-mile tributary of the Yellowstone that meets the larger river near present-day Laurel, Montana; this is not to be confused with the much larger Clark Fork River of the Columbia. Early speculation in the area immediately foreshadowed the unfeasibility of an effective method of transportation to and from the mines. The *Avant Courier* honestly stated: "it is known that the richest kind of ore abounds in that section, but the great need is facilities for transportation and reduction, and some parties will devote themselves to the task of finding a practicable wagon road." The newspaper gave their support, proclaiming, "we hope they may be successful."[1] Regardless of transportation issues, the fever continued into that fall, when there were "about 200 men in the neighborhood of the Clark's Fork prospecting," as reported by Deer Lodge, Montana's *New North-West* on September 13, 1873.[2]

Just two years prior to the *New North-West* report of "200 men," the paper had printed skeptical articles as to the wealth to be found in the mines and the difficulties in traveling to that region. The *New North-West's* skepticism was aimed directly at Bozeman's *Pick and Plow*, the short-lived first paper published in Gallatin County. Starting in early 1871, the *Pick and Plow's* editor, H.N. Maguire, had published wildly enthusiastic articles about the Clarks Fork mining prospects. The *New North-West* accused Maguire's paper of continuing to "publish and overflow its columns with the most exaggerated

and absurd statements conceivable of their [the mines'] richness, the rush thither, and the depopulation that is ensuing in the older camps of Montana." The *Pick and Plow* accused all other territorial papers "of purposely keeping silent or disputing its statements, lest the effect be disastrous" to their localities. The *New North-West* claimed Maguire's stories were "imaginative and totally unreliable," even though it grieved them to "say this about a brother quill." They conceded that there "may be mines discovered and developed there hereafter" and that it was a "splendid country" that could be ranched if "the Sioux don't lift the hair of the adventurer." They even agreed to republish any credible statement about the mines written in the *Pick and Plow*, if affirmed to be true, in the columns of the *New North-West* in a "conspicuous place," but overall deemed the paper unworthy of credence.[3]

On April 14, 1871, an article in the *New North-West* stated, "we last week avowed infidelity in the too much celebrated Clarks Fork gold mines. We lacked Faith, 'which is the evidence of things not seen:' therefore we are infidel. Faith is good; as relates to placers, it is but a speculative pleasantry." Discussing reports from Bart Henderson, explorer and early discoverer of the mines, the paper wrote that he was "favorably impressed with the appearance" of the land and had "believed for years there would be mines found there" and that he had indeed "obtained encouraging prospects." It was reported that many believed Henderson had a "sure thing on the mines, and is 'keeping shady' to get his friends in before a stampede." Despite his good words on the mines, the paper concluded: "It is not improbable mines will be found there, but it is to-day as extremely dangerous Indian country, not prospected to any considerable extent, scarce explored, considered inaccessible before June, three hundred miles beyond Bozeman, and over a country in some portions so ruggedly mountainous that trails had to be graded for pack animals to get over."[4] That summer, the *New North-West* stated that "no paying diggings" had yet been found, no sluices set, no prospecting had been done and, in short, "many of the stampeders are very much disheartened and doubt the existence of rich gold mines in that section."[5] Within two years, this statement would be a null point.

As more and more men found their way into the valley during the latter part of the 1870s, the issues of land ownership began to rise. The Clarks Fork mines lay almost entirely within the Crow Indian reservation as set out by an 1868 treaty. This fact did little to deter the miners, as in 1876, the first mining company in the area was formed. The Eastern Montana Mining and Smelting Company was established by a group of miners who put their properties together to form a joint stock valued at $7,500. It was reported

that the property owners, "W.C. Davis, John Ponson, George Craig, Judge Annis, Baronett, Miller, and A.B. Henderson," had "over two hundred tons of ore on their different dumps, with plenty more in sight in the mines" and that they intended "as early as possible this coming season, to build a furnace for the reduction of their ore into bullion." It was also noted that "there is in this Company experienced and practical men enough to do all the work and carry it on, taking shares in the stock for their pay."[6] Experienced indeed, both Miller and Henderson had been present in 1870, when the virgin land had first offered a glimpse of her mineral wealth.

INDIANS ALL AROUND

Twenty years prior to the initial discovery of gold in the valley, in 1859, an eighteen-year-old immigrant from Bavaria was making his way west from St. Louis. He was a championship bare-knuckle fighter and a young man longing for an adventure. Gay Randall, who knew Adam "Horn" Miller in childhood, wrote:

> *stories of the raw, lawless land, and a dare-devil life intrigued Horn, as did the pokes of coarse gold and bales of valuable raw furs, so he decided to sample this new life first hand. He was disgusted with the filthy waterfront. The plowed fields and corn patch held no appeal for him.*[7]

His first years out west consisted of fur trapping and trading until he became interested in prospecting. In 1870, Miller set out in the initial discovery party of four toward what would become his home for the next fifty years. If Miller had been looking for the unmitigated "wild West," he surely found it in the Clarks Fork region.

In 1927, the *Choteau Acantha* of Choteau, Montana, would publish an exciting recount of the early discovery of gold in Clarks Fork as told by James Gourley, who was then eighty-seven years old. In the interview with M.E. Plassmann, a pioneering woman in her own right who often wrote for Montana newspapers, Gourley described how Miller and himself had been left alone at their camp when a band of Sioux drove off the horses. After making his way back to camp, regardless of having "Indians all around" him, he called to Miller "not to unload his rifle except to kill for sure" and fired as the leader of the band turned towards them. Having been in similar

Horn Miller, early explorer of the Clarks Fork area. *Yellowstone Gateway Museum of Park County, 2006.044.0833.*

situations in the past, Gourley noted that "an Indian will not attack where they are sure of losing man for man" and that they would "smoke before they attacked again." With this in mind, the two men dug a "breastwork" of at least a foot in an attempt to create a defense against attack. When this work had been completed, Gourley "received one certain good hunch" and "went to the rim of a narrow, deep coulee" to call out as though he had seen their two partners, Ed Hibbard and Bart Henderson, coming. The Indians took notice, and Gourley saw that four of them were standing behind a ridge ready to shoot them "down like cattle" if they made for the coulee. Gourley noted that "it seemed a long time waiting—Lord, how long! before they [Hibbard and Henderson] came."[8] A.B. Henderson's journal also contains a brief paragraph about the encounter with the Native Americans:

A short distance further we came in full view of the whole scene We saw at a single glance that the camp was surrounded by Indians who already had our horses in their possession…we soon picked a safe locality and joined in the action the first volley we fired was the last, as the Indians were soon in full retreat, supposing themselves surrounded.[9]

With the additional reinforcements, the miners felt confident about protecting themselves against an ambush, and the next day, according to Gourley, destroyed "everything that might be of value to an Indian and poisoning any article they would like to use."[10] However, Henderson's diary of the time notes: "August 1, 1870 Clear and cool. Left camp at noon. Our whole outfit consisted of the following articles. Flour 20lbs, coffee 15lbs, sugar 40 lbs, salt 4lbs, tobacco 10lbs, ammunition 25lbs. Camp kettle, fry pan and axe. We left everything else in tent—21 traps and 27 bearskins." The group carefully made for Bozeman, about two hundred miles away, attempting to not leave a trail. The journey must have triggered irritability, as Henderson also notes: "Dad and Horne quarreled about a dog, drew guns and knives. I cocked my gun and told them to stop quarrelling—camped near East Fork."[11] It was on a return trip that Gourley found out just how closely they had been followed. At the head of the Boulder River, according to Gourley, they threw out all of their meat, "believing in an hour we could get game." Unfortunately, flies had driven the wildlife up into the mountains, and they found themselves "one night and two days without anything to eat or drink except a little tea" until they found and "gorged on fish with serious results to some." The group wasted no time in preparing a return trip. Gourley acquired seven Springfield rifles and "about 1,000 pounds of ammunition," stating that "the means of doing so would have been criminal under any other circumstances." The men now headed for Clarks Fork in a party of eight who all started "by way of Boulder." It was then that Gourley found the tracks of his own horse that had been stolen by the Sioux and realized that they had been followed for quite a while by the band of Native Americans during their flight a few days earlier. On safe arrival, the new group "sunk a shaft 30 feet deep" before they encountered a snowstorm, which forced them to shovel snow so that their horses could reach the grass for days in the middle of September.[12]

During this return trip, the group made a startling discovery. The previous winter, miner Jack Crandall had shown Miller samples of the tracer ore he had found on the Soda Butte. The four men had meant to meet up with Crandall and his partner Doughtery when they had first arrived that Spring.

They hadn't shown, and, of course, the foursome had been forced out of the area by that band of Sioux. Now, they discovered that both Crandall and Doughtery had been killed, hence their not meeting up with them. They were found with their heads removed and placed on their picks, cups laid before each one. However, not even this sort of violence could deter men from their search for "color" and the promise of good prospects.

THE GREAT HUMBUG

News of a gold strike in the Clarks Fork area rapidly spread that first winter, mostly shared by the discoverers themselves, it is supposed. In May 1871, the original explorers again gathered to take a trip to the new region, finding a grouping of seventy-four men waiting at Slough Creek (about thirty miles distant). They all banded together to make the journey, which proved to be extremely disagreeable to many of the stampeders. On June 5, Henderson noted that a committee had been appointed to create a code of law with which to govern the new district. On June 7, the laws were read, and Major Farrow was elected the recorder. The following day, Henderson writes:

> *Cloudy and cold. Lively times in camp. Some of the men threatened to take Miller and myself out to compel us to show them our diggings…we told them the first man that made a move towards forcing us would fall martyr to his foul and rash undertaking. This put a stop to further threats.*

He goes on to note that the recently elected recorder gave a speech of resignation, and the grouping soon disbanded, "so the beautiful outfit left the camp, without sticking a pick in the ground cursed the country, the discoverers and themselves, for coming to the great humbug, which they created themselves."

The original gang stayed, along with some stragglers, and continued improvements on the camp. A corral was constructed, and two men were put on guard to watch the horses; the long walk out of the region was not to be a repeat event. Most of the summer was spent checking on claims, improving living areas and exploring the surrounding region. In this way, Grasshopper Glacier, which would attract many a tourist in the 1920s and '30s, was discovered. While most stayed in the region till fall, Henderson took an annual trip back out to Bozeman to celebrate the Fourth of July. On

Remains of Yankee Jim's National Park Toll Road, constructed in part by Bart Henderson and Horn Miller. *Yellowstone Gateway Museum of Park County, 2006.044.1894.*

his trips, he raised speculation in town as to whether the gold rumored to be in the Clarks Fork region was profitable or not. Some, including the *New North-West*, thought Henderson was "keeping shady" on the real wealth to be found there, while the *Pick and Plow* promoted the area extensively. By August 1871, Henderson was back near Gardiner helping to build a road through the canyon to the west that would be known as Yankee Jim Canyon.

In May 1872, the camp was again called together to create laws that would govern the mines, now to be called the "New World District." Soon after, the Miller Lode was the first recorded in the district. Of course, the claims were not technically legal, as they all laid on Crow Reservation land. Interestingly, the men, including Henderson, returned year after year in May, each time finding the snow too deep to do much work. One must wonder

why they chose to arrive so early knowing this condition. On June 12, 1873, Henderson noted: "Clear and warm. Visited the mines, found most of the lodes covered with snow from 2 to 1 feet deep, while a few clear of snow. Most of the party are already becoming discouraged and think the snow will remain all summer. I think different."[13] The following day, a large grouping of stampeders arrived, and plans for "Galena City" were laid out; the name wouldn't stick.

Trespassers upon a National Pleasure-Park

It was not until the 1920s that stories of the first discovery would be widely publicized across the state of Montana. However, these men were not just miners. In 1877, Horn Miller was earning his reputation as a guide when Yellowstone National Park superintendent P.W. Norris was making his extensive explorations of the region. Norris's 1877 report told how "Mr. Adam Miller" had been employed by Norris as a guide and explorer. Miller was tasked with investigating a potential pass from Slough Creek to the Rosebud. As Norris noted, this pass could cut off "nearly one hundred miles in distance and several canons and mountain-spurs along the Upper Yellowstone" that would prove to "at least the East and Clarks Fork mining regions, much if not all of the year, exceedingly valuable, if only for pack trains, with strong promise of a wagon route from the navigable waters of the Yellowstone past the Crow agency." Norris's awareness of the mines was grounded in concerns over the relationship between the miner and the boundary of the national park. It was a known fact that the mines of Clarks Fork had been found a couple of years prior to the establishment of Yellowstone, albeit on Crow reservation land. As Norris correctly observed, the "occupants of these mines have labored in utter ignorance of whether they were living under the usual regulations of mining camps, or trespassers upon a national pleasure-park." The presence of Montana capitalism had provided a smelter for the region and brought in a workforce of "thirty or forty resident gold-placer miners." For Norris, the situation was characterized thus: the "ownership and development of all these mining interests are so dissimilar to the anomalous rules and regulations necessary for the management of a wild national pleasure resort, that antagonism and annoyance so arises and increases at every phase of their contact." He declared that the "permanent good of both

absolutely requires a speedy survey of the boundaries of the park, followed by either a recession or special rules for management of these, probably the only valuable mines that will ever be found even partially within the park."[14] The issues outlined by Norris at this early date are premonitions of the long conflict the mines would have with the park in the decades to come. The politics of boundary lines would drop from Norris's and Miller's minds that September, however, when the Nez Perce entered the national park.

As mentioned by Norris, "the unexpected Indian raid" prevented Miller from the immediate reporting of his findings. Miller would lend his knowledge of the area's landscape to General Howard, the former Union general who would lead the campaign against the Nez Perce. In September 1877, S.G. Fisher was leading Bannock Indian scouts with General Howard when he asked Miller and local pioneer George Huston to join in the pursuit of Chief Joseph and the Nez Perce. In 1872, George Huston had visited the Clarks Fork region as a guide for F.V. Hayden, although he certainly may have been the first prospector in the Yellowstone area before then, which would account for his abilities as a guide. Like Miller, he knew this land like the back of his hand and was a huge asset to the military. Later, Redington would write of the "rough riders" who had comprised his outfit and note that George Huston was "one of the best" and Horn Miller was "one of the best old souls that ever lived."[15]

The year 1877 was dominated in the press by the flight of the Nez Perce, an event that would become legend in Cooke City history. The *Benton Record*, based in Benton, Montana, reported on September 7: "the Clarks Fork miners are alright. Last Wednesday they were on the lookout for Indians. No danger there."[16] On September 14, the *New North-West* reported a skirmish: "3 scouts started, but they fell in with the Indians and were surrounded and attacked near Clarks Fork mines; one of the scouts (an Indian) was killed; another (a white man) was wounded"[17] When looking at articles of the time, this is the only one that mentions any incidents near the Clarks Fork mines.

The Nez Perce left some evidence of their passage through the park, as noted the following year by the *Rocky Mountain Husbandman* (Diamond City, Montana) on June 13, 1878: "The Yellowstone [Barronette's] bridge, on the road to the Clarks Fork silver mines and the geysers, which was burned last fall by the Nez Perce, has been rebuilt, so that parties will find no difficulty in crossing the Yellowstone at that point."[18] But, relatively little documentation exists that shows what impact the Nez Perce had on the new mining camp (besides the burning of the bridge).

Horn Miller (*left*) and his mining partner Pike Moore (*right*) at a cabin. *Yellowstone Gateway Museum of Park County, 2006.045.1436.*

By 1936, Cooke City and Horn Miller had become legendary in the flight of the Nez Perce. While the facts may not always align, the fiction does present a lively tale of the fledgling mining camp and its people.

A rousing article appeared in the *Choteau Acantha* on January 16, 1936, that portrayed this legend in the making. The author of the article, Glendolin Damon Wagner, drew a comparison between the miner and the Nez Perce tribe: "it was at this time, while the fever for gold was in men's veins and while the little mountain town was putting up a determined struggle for existence that the Nez Perce tribe started on the warpath, they too, struggling for their tribal existence." Most of the drama in the article lay in the anticipation of their arrival in the area, the tribe "spreading horror and bloodshed in their wake, splitting the mountain silence with their yells" while General Howard drove them "straight through the valley sheltering Cooke City." At the time this article was written, Horn Miller had become the father figure of Cooke City and the surrounding mines. Wagner wrote: "It was then, too, that Horne [*sic*] Miller, giving up, for the time, his prospecting, sat night after night in that log cabin of his which still stands in Cooke City, molding lead bullets from his quartz, grimly prepared to do his part in defending the town he had helped to create," while reports came in "day after day" from scouts that "the Redskins were advancing." According to Wagner, a raid of Cooke City had been a strategic goal for

the fleeing tribe "with its smelter whose lead would supply them with much needed bullets for their rifles." The article stated that they did "raid the town, despite the courageous defense of the few whites, and captured the smelter, taking with them, in their headlong dash toward the trap General Miles had set for them, all the bars they could carry."[19]

Later articles report that the smelter was burned to the ground, and various buildings were destroyed. However, no articles at the time of the Nez Perce flight report any such incident, leading one to believe that time has led to a false accusation being made against the fleeing group and an exaggerated story of perseverance created on behalf of the miners—all in the name of tourism.

CAPITALISM AND THE EARLY PUSH FOR A RAILROAD

THE NEW TOWN WAS UNANIMOUSLY NAMED COOKE CITY

Sitting in Philadelphia in 1870, Civil War financier Jay Cooke had his mind on tourism and the development of the Northern Pacific Railway, in which his firm, Jay Cooke and Co., was heavily invested. Cooke had heard stories of Yellowstone—stories that had hit at the heart of him in more than just a business sense. He found fascination with the landscape of the West and had decided to be a part of it all. As such, his life and that of Nathaniel P. Langford collided. Langford would become the first superintendent of Yellowstone National Park, a title made possible in part by his time spent working for Jay Cooke. For Cooke, the meeting would serve as a means of exploring the area called Yellowstone, which he could turn into promotion to construct a railroad there. As a businessman, Cooke knew he had to define a need. He had to get the public interested in the area so that the Northern Pacific could cater to their wants. As Yellowstone historian Aubrey Haines wrote,

> *A visit with Jay Cooke in Philadelphia…evidently led to some understanding between them concerning the usefulness of Yellowstone exploration in the grand scheme of Northern Pacific Railroad publicity. The need of the moment was for promotional material useful to Jay Cooke & Company's task of financing the Northern Pacific Railroad.*[20]

The Hayden expedition of 1871 was driven by this arrangement with Langford and put Cooke into a position to generate the kind of publicity he was seeking. He got an eager Thomas Moran to join the expedition, loaning him a portion of the funds necessary while *Scribner's Magazine* put up the rest. Moran's resulting work, *The Grand Canyon of the Yellowstone*, with its awe-inspiring depiction of the area, would become a driving force in establishing Yellowstone National Park. The overall scheme proved effective when the park was established on March 1, 1872. Unfortunately, within a year of this accomplishment, Jay Cooke experienced a financial downfall (known as the "Panic of 1873") that was felt across the nation, and his ties to the Northern Pacific and his banking house were all but severed. However, by 1880, he had gained much of his fortune back and again had eyes on the West. An investment in the Horn Silver Mine in Utah had played heavily into the re-creation of his vast financial empire. It is this mine that brought his name into the Clarks Fork area.[21]

Jay Cooke's influence with the Northern Pacific had fallen in the Panic of 1873, but his interest in a good investment must have kept him tied to railroad endeavors and the area surrounding the park he had helped create. Early in 1880, word was out that Jay Cooke and/or his son had become involved in the Clarks Fork mines. The *Helena Weekly Herald* prematurely reported, "this week a company of Eastern capitalists, of which Jay Cooke is the head, purchased the Great Republic and another mine…for $100,000" and noted that the "Eastern Montana Mining and Smelting Co., have also bonded their mines and property to the same parties for $50,000."[22] By early June, a party of capitalists had been assembled—including the financier's son, Jay Cooke Jr.—with the intent of visiting the Clarks Fork mines while en route from the Horn Silver Mine of Utah. The party was also anxious to see Yellowstone National Park, and it seems that the Clarks Fork mines were just a convenient destination point with some financial potential on the pleasure-trip portion of the journey. For those located at the Clarks Fork mines, however, this portion of the trip held much promise.

At a meeting of citizens on June 11, 1880, the camp received its name, proudly establishing a connection with a promising future. The *Bozeman Avant Courier* published the minutes of the meeting, which included the following: "on motion of John G. Stevens, the new town was unanimously named Cooke City."[23] Those present included promoter of the mines T.W. Bates, the soon-to-be county assessor Z.H. Daniels, explorer and entrepreneur C.J. Baronett, Cooke City's "Judge" H.B. Potter, Yellowstone National

Park superintendent Colonel P.W. Norris, mining partners J.H. Moore and Horn Miller, Crow Indian agent F.D. Pease, miner George Fisher, George S. Flemming (who would bring a "wagon lode of lace"—women—into camp) and miners James Gourley, A.B. Henderson and George Huston, among many others. In all, more than fifty people were represented at this monumental meeting.

Almost concurrently, the party of investors was busy making the necessary arrangements to best use their time at the mines. According to Mrs. Edward Eltonhead (wife of the mining expert and assayer for the party), the group had made contact with the company Allis and Chalmers to have the "necessary mining machinery and office supplies…shipped directly to the Clark's Fork Mine[s] to be in readiness for the further developments" they intended to make upon their arrival there.[24]

Throughout the coming months, the *Helena Weekly Herald* continued to publish articles about Jay Cooke's mining interests in the area, and by July 1, 1880, the camp was expecting a visit from a representative of the company now in the party of Jay Cooke Jr. The *Bozeman Avant Courier* applauded the work and character of T.W. Bates, seemingly an integral part of Cooke's involvement. The author of the article called themselves "Richmond" and

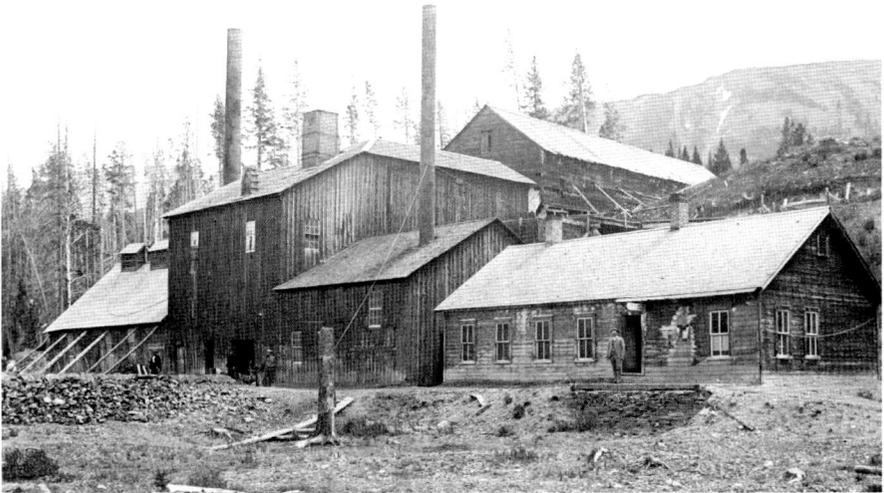

Republic Mine smelter and office. *Yellowstone Gateway Museum of Park County, 2006.045.0515.*

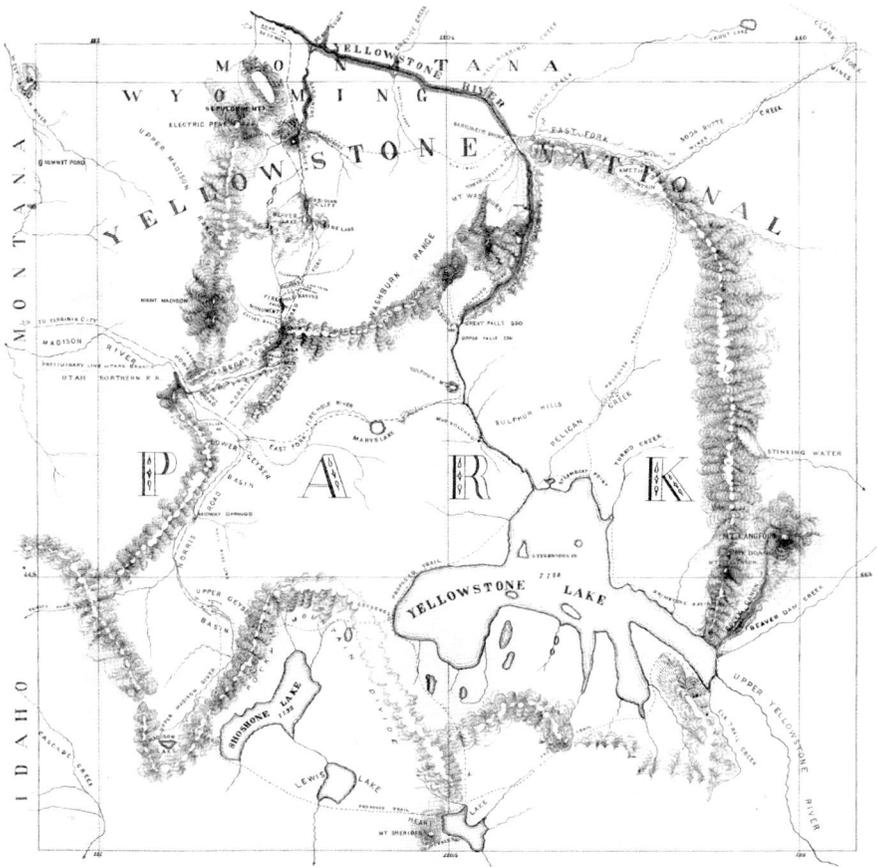

Yellowstone National Park map, 1878, with "Trail to Mines" and "Clark Fork Mines" clearly marked in the upper right corner. *Archives and Special Collections, Mansfield Library, University of Montana.*

stated, "He gives the boys hope whenever he is around…I have not heard a word or whisper against him. The boys all like him for assisting so much in bringing our whereabouts before capital. He is a staunch friend to us all, and a worthy gentleman, in every sense of the word."[25]

Richmond's article of July 1, 1880, did more than drum up excitement—it brought up the issue of transportation to the mines, correctly asserting the necessity of a proper wagon road from Gardiner, and there was no doubt that the issue must be resolved by the government. The article states, "we must see Colonel Norris and try to enlist him in helping us out, as the most of the road is within the limits of the Park."[26]

As Mrs. Eltonhead would later note, the mines at the Clarks Fork had "a peculiar situation for it was at the junction of the Park, Wyoming and Montana and a suspected man could walk out of the jurisdiction of any place and be free."[27]

This also inherently meant that a miner could never truly be sure where he had staked a claim, showing the need for clear boundary lines around the park. Richmond was also correct when he mentioned the need for the ratification of the Crow treaty to legally entitle the mine owners to their mining claims. But Richmond confused the level of Jay Cooke's involvement in the mines, as he notes that they "expect Jay Cooke & Co., or agent, soon, to examine mines that are bonded to them."[28] At this point in time, Jay Cooke was no longer a part of Jay Cooke and Co. His position in the company had been dissolved about the time of the Panic of 1873. Now, whether Richmond was intending to refer to the actual company or just to a group of men headed by Jay Cooke with no relation to the company of that name, one can't be sure. Richmond believed that the mines had been bonded for "a mere nominal figure" and stated that he had "talked with owners who don't seem to care much whether they take them or not, as they are satisfied that, by another year's work on the mines, they can be sold for two or three times the amount."[29] One could certainly argue that the miners did indeed care whether they took the mines or not. After all, the town had only just made its debut under the name of Cooke City. They surely saw opportunity in that name and its connections—an opportunity they would hardly shrug their shoulders at missing.

The End for a Season Was Reached

The *New North-West* of July 16, 1880, published the first conclusive article that confirmed that Jay Cooke Jr. was indeed in Montana Territory; in fact, he was as close as Bozeman. The newspaper reported that "a party of capitalists" that included "J. Cook, Jr." had arrived in town "for the purpose of visiting Southeastern Montana, but especially the Clark's Fork mines."[30] Soon after this announcement, the party headed to the mines, gathering members as they went, including four guides, two hunters, a cook and fifteen miners. This additional group included George Huston, who had interests at the mines and extensively knew the land. Mrs. Eltonhead beautifully detailed the party's first look at Cooke:

One day at sunset – the last hill was made and a deep little creek known as Crandall Creek sighted – two logs were thrown across for a bridge – and was just wide enough for one poney at a time, so one by one the outfit trotted up the grassy road past three cabins with no windows – no people – no anything – save the encircling Mountains – the song and chirping of the birds – the wind in the tree tops – up the road a little farther still - a tiny Park about ¾ of a mile long – 4 wide – one solitary Log cabin was there – and the end for a season was reached for this quiet, deserted place was Clark's Fork – the Cabins were Cooke City.[31]

According to her, within a week, the majority of the party moved on, while she, her husband, two miners and the cook stayed in camp. They quickly made improvements to the small cabin they occupied, which included sawing through the door to let in light, as "Cooke City did not have a trend towards windows." She noted at this time that "the Great Republic work had begun in earnest to see if the proposition was one of real commercial value to the Eastern Men."[32] It seems that ore was taken from the mine to a little assay office that had been assembled in one of the empty cabins down below, and the smelter had been repaired to working order.

Meanwhile, on July 29, the *Helena Weekly Herald* printed a positive report of the overall visit, albeit slightly lacking in detail: "The Jay Cooke party are reported to have consummated the purchase of the bonded Clark's Fork mines, the purchasing price being $100,000. Young Mr. Cooke and associates returned East by way of the National Park and are probably now viewing the sights in that region of wonders."[33] There was no mention at this time of the party left behind to maintain investigations of the mines.

There is one thing of note in this short description of Jay Cooke's visit. The words "Young Mr. Cooke and associates" indicate that Cooke Jr. was in the company of this party of capitalists throughout the visit to the Clarks Fork mines. His placement in Bozeman, followed by him accompanying capitalists back east "by way of the national park," seems to indicate that he did physically visit the small mining camp of Cooke City. Mrs. Eltonhead did not mention Jay Cooke Jr. more than once or twice in her reminiscences of the journey, giving us little proof that the son did indeed join the group on the journey to Cooke. The three sources provide reasonable proof of his actual visit. It would not be until the 1920s that the story would be told any further. By then, it was said that a party was given in Jay Cooke Jr.'s honor,

after which the town was renamed "Cooke City." This, of course, does not fit in with the timeline of events as recorded above.

Another letter by "Richmond," dated July 22 and published in the *Bozeman Avant Courier*, gave more insight into the interest of the investors, and while maintaining a hopeful ring, it does present the issues that would plague progress: the hindrance of the Crow reservation and the desperate need for economical transportation. Richmond writes: "I expected to inform you in this letter of scenes and pictures of a busy mining camp, but such cannot be, owing to the fact that our bonded mines were not sold. The only reason that the sale was not consummated was in the title. Jay Cooke & Co. were highly pleased with the property, and seemed to regret, as much as we, our still being on the domain of the 'noble red man.'" According to the letter, the party of capitalists had "remained three or four days, and were lo[a]th to leave, but had to return East within a stated period." During that time, they had "examined several mines outside of those bonded" and "spoke in flattering terms of the prospects." In fact, they were so interested that they had taken the time to examine the Clarks Fork Divide to see if it could be navigable to a branch of the Northern Pacific, which they reported was "feasible." According to Jay Cooke's original plan, the line would be built for the purpose of "bringing these mines into railroad communication, and also for the benefit of tourists visiting the Park." Such a road would cut through the Clarks Fork down to Soda Butte creek and out past Mount Washburn through the park to Madison Valley. Richmond had learned that the party intended to have this route surveyed "at as early a day as possible," as well as a survey up the Yellowstone to Bozeman. As to the mines, Richmond wrote that "it will not positively be known until after the Crow treaty is ratified," but that many thought "their intentions are to take hold and push matters here as soon as a title can be given." Money in the amount of $4,000 to $5,000 was to be expended on three mines, the Huston, Greeley and Great Republic—the results of the explorations to virtually decide the matter.[34] The *Helena Weekly Herald* of September 9, 1880, does again point out that while no business could be transacted in an official capacity, there must have been some understanding between the mine owners and the capitalists. It was noted that E.Y. Eltonhead was "about to commence the prospecting of a number of mineral locations on Clark's Fork in the interest of Messrs. Jay Cooke, Thompson, Butler and other Eastern capitalists."[35] During this time, according to Mrs. Eltonhead, the "development showed that the Ore was there but was not a free milling ore…and the cost of transportation was too great to make it a

paying investment as a Stock proposition in the east." She notes that there was "much of disappointment in Bozeman—Helena—and in Salt Lake City—when on coming down from the Mine—the rumor spread that the investment could not be recommended."[36]

The party left the area late that year, just before the snow began to deepen. Mrs. Eltonhead noted that "the trip down was rather hard—the first two days beautiful—and the Stone Sentinel on the Peak was hard to say good bye to, but then the snow began to fall—the cold was bitter towards night—the trail heavy by day."[37] Nothing was noted in the newspapers about their journey from Cooke City back to the East. It seems that the rumors had left all disappointed and few interested in the departure of this particular party.

It would be nearly two years before the Crow treaty would be ratified to suit the miners and their mines. During these two years, the miners would push forth with their work while living in a camp named for Jay Cooke, the capitalist who could make their dreams come true, on the "domain of the 'noble red man.'"

Richmond's description of the possible railroad routes perfectly set the tone for further discussion of transportation matters. In the early years of the mining camp, cost-effective transportation of goods seemed to only entail the interest of capitalists and a good showing of mineral wealth to aid in that interest. Notice the way in which the Yellowstone route is mentioned in Richmond's article. It is listed as the "most practicable route" with no qualms about traversing the national park. There is no indication here of the issues that would arise in attempting to run a rail through this protected landscape. This subject of transportation would unfortunately become attached to any discussion of profits to be made in the mines, as noted by the *Helena Weekly Herald*: "The mines are not accessible to wagons, and all supplies and material have to be packed in by mule train."[38] Potential investors would have to take into account the transportation necessary to make a profit, and while some, like Jay Cooke Jr. and his party of capitalists, prominently figured the railroads into their schemes, to many, it was an indisputable detriment to investment and progress.

With all the news coming out of the camp in 1882, not one mentions a current update on Jay Cooke and his investments—a telling note on the fickle interest these mines were to receive in the years to come. In the 1920s and 1930s, in-depth retrospective articles on the history of Cooke City would confuse the order of events during which Jay Cooke faded from the scene. They would surmise that the Panic of 1873 ruined Cooke's investments,

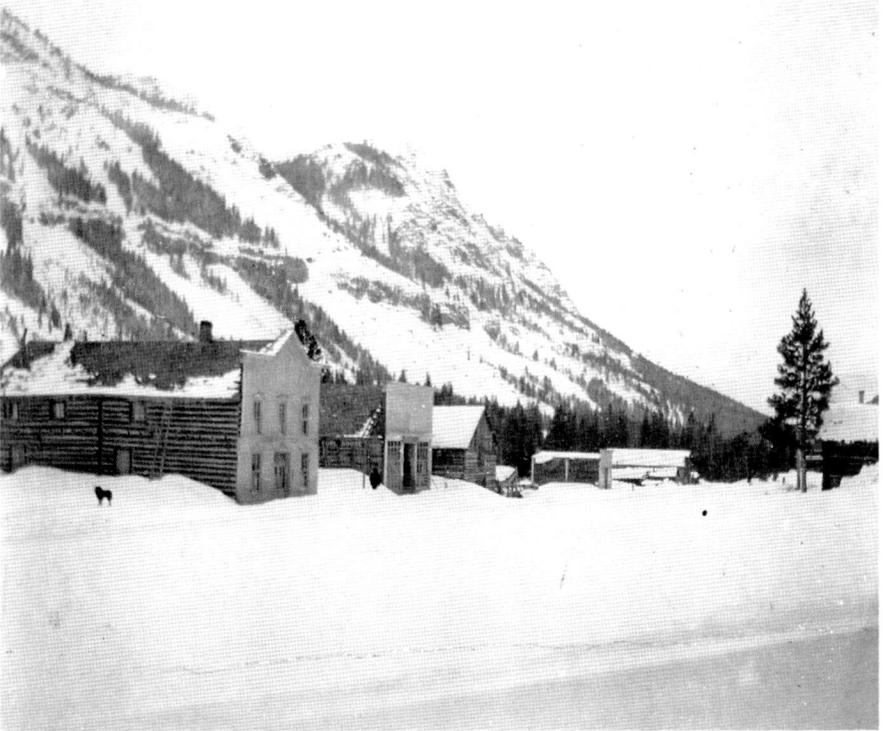

Winter scene looking west; Curl House is the first on the left, with Republic Mountain standing as sentinel. *Kathy Kleppinger, Tredennick family.*

but the reality seems to be that in the time he had to wait for the Crow to cede their land, the financier must have lost interest in the prospects. While Cooke had the means to provide the transportation, the struggle to build a road to the mines outweighed the will to fight on his part.

However, some did not forget the time spent at Cooke. Mrs. Eltonhead concluded her reminiscence thus:

> *then the wheels began to turn – the engine puffed – the whistle and the Summer was over but never the memory of the Wonderland – nor the Mountains – nor the rivers winding like silver ribbons among the Fir trees as seen from some great Divide – never the memory of the people of the Territory who evinced then the same qualities which they show as a State – fair-mindedness – progressness and kindness to one and all who come with-in their borderland.*[39]

EARLY LIFE IN A MINING CAMP

No One Need Hesitate about Coming Now

With the development of the mines and a new influx of men, news of Cooke City became more centered on people rather than issues and ranged from the humorous to the tragic, reminding one of the rough life prospectors faced with what laughter they could afford. The *River Press* related a story first printed in the *Bozeman Avant Courier*, titled "Shrewd Mr. Smythe—How the Old Timer Played it on a New Yorker," a story that was "deserving of being immortalized in print." It seems that around 1880, a party of Eastern capitalists had purchased the Silver King Lode and sent out a "dapper little chap" of a superintendent "who knew no more about mining than a Crow Indian does of geometry." The man, Mr. Smythe, arrived in Bozeman in November and promptly hired cooks and teamsters for future work at the mines before making his way to the property. He quickly determined that a tunnel must be dug to access the minerals and asked for bids. As the article notes, "an old-timer and prospector" by the name of Johnson "went to see the embryo superintendent," where it did not take him long to "'size up' his man, and in a short time he had contracted to run a tunnel on the lead to a depth of 225 feet." The endeavor was to cost the company "$20 a foot, or $4,500 for the work," and Johnson was paid $1,000 on the spot to begin the project. There had been considerable snow on the ground that November, so when the old-timer began his tunnel, he worked away from the mountain side, digging through the snow instead, making his workload light and the

appearance sound. He closely timbered the mouth of the entrance and laid track a short distance into the snow tunnel, then "littered the roadway" with a car or two of waste to give the "appearance of a veritable tunnel." In late January, he wrote to Mr. Smythe to say the tunnel was complete. When the superintendent arrived, Johnson presented him with "the end of a rope which was exactly 225 feet long, and told him he need not soil his clothes: that the tunnel was very wet, and that when the end was reached he would strike the face with a hammer." When this was completed, Mr. Smythe promptly paid the old-timer the remaining $3,500 and "released him from his contract." Six months later, the superintendent returned to continue work on the mine to find timbers strewn across the mountainside and no tunnel; he had been "taken in." The old-timer headed for Tombstone, and Mr. Smythe was not heard from again.[40]

This idea of "playing it" on visitors, investors and tourists alike would continue throughout the years with many variations. With all winter spent waiting to get back up on the mountain, these men must have had more time on their hands than was advisable. In the tradition of John Coulter, one miner gave a glimpse into life at the mining camp to the New North-West. Jim Ponsford, who had been present at the naming of the township, wrote the newspaper, stating that the "snow has gone off very rapidly in the last few days, and that wagons can now go through to the mines without difficulty. No one need hesitate about coming now." He also noted that there was "no feed in the vicinity of the mines, but there is good grass at a place about twenty miles this side, where a herd of horses are being kept," and that claims "that are not properly staked are jumped without hesitancy by the new-comers." This credible account of life in the mining camp ended thus, with Ponsford saying that, one day, "I thought I saw some curlews, and I got my gun and shot at them, but when I picked them up I found they were only Yellowstone mosquitoes. The sons of guns sink through the flesh until they strike a bone, and then they go for the marrow." The story concluded: "Jim was never known to exaggerate."[41]

Snow in these mountains lasted well into the summer months, giving miners little natural opportunity to work their prospects. In later years, many would stay year-round to work the claims despite avalanche threats. This was a harsh climate, but these hearty men met the challenges head-on. The claim-jumping described in Ponsford's update shows the social climate—again, harsh. This was hardly the place to raise a family, and yet the women came. The first mention of a woman in the mining camp came in August 1882, when a New North-West article stated: "An enterprising woman

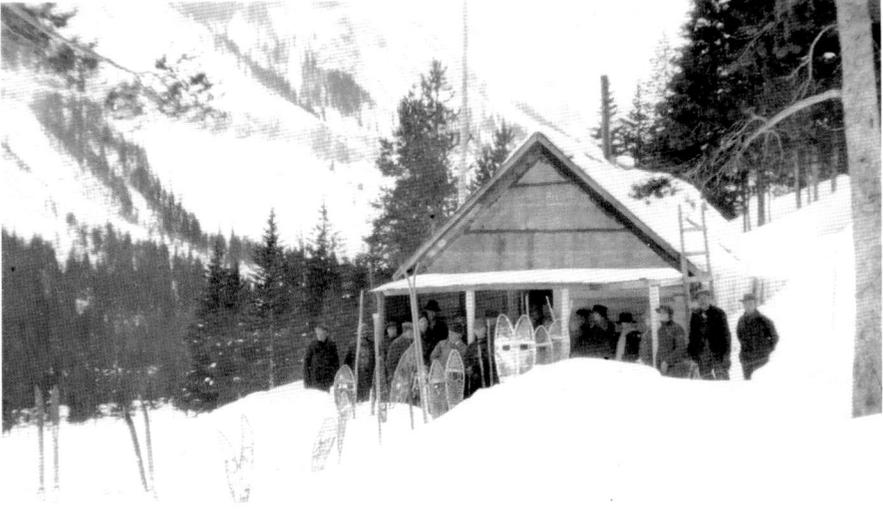

A group of snowshoers gathered at a cabin below Republic Mountain. *Cooke City Montana Museum.*

has taken four cows to the Clark's Fork mines and is selling milk at 25 cents per quart."[42] This note also indicated that a new industry was growing in the mining camp—serving the miners. Within the next couple of years, the town would grow, and men like the enterprising Jack Allen, proprietor of the brand-new Cosmopolitan Hotel, would be ready to serve capitalists arriving in town to view their prospective investments.

The remainder of 1880—and most of 1881—brought little news from the Clarks Fork region. The matter of the Crow Reservation left the miners without hope of investments from those like Jay Cooke. Work continued, but only in the most minimal amounts. In May 1881, the *Helena Weekly Herald* reported that a number of miners were headed back out to Clarks Fork for summer representation. The mines were still young in their discovery, and the promise of a train still whistled in their ears.

One Thousand Stampeders

The year 1882 marked a change for the mining camp, and the first reports from Cooke start the year off in anticipation. The *New North-West* proclaimed on January 6, 1882, that "a new town called 'Jay Cooke City' has been

started in the Clark's Fork district."[43] The *River Press* reported the same. While many had used this name over the last two years, this is the first time a newspaper used it in reference to the township. Word must have been out that the Crow treaty was under negotiation, and a decision would be soon to come. By April, the treaty had been broken, and the land of the mines was thrown open to ownership and investment. The *Helena Weekly Herald* told of the news on April 13: "By the provisions of the Crow treaty the Indians cede to the United States a large tract of valuable mineral and agricultural lands, lying south of the Yellowstone and near the line of the Northern Pacific and including the rich and well known Clark's Fork mines."[44]

The *Benton Weekly Record* made the same announcement seven days later, noting that within the 1,000,000 acres ceded, the "released section embraces the Clark's Fork mines, discovered in 1872, which are said to be fabulously rich."[45] The Clarks Fork mines and the Northern Pacific both figure prominently in these reports, signifying how important the mineral wealth of the mines and the influence wielded by the railroad company were in ratifying the Crow treaty.

Local newspapers praised the quality of the mines, which were now open to development, while honestly informing stampeders of the conditions to be encountered. The *River Press* of April 26 reprinted a report from the *Bozeman Courier* saying that "there is considerable excitement and talk, especially East of here, regarding the Clark's Fork mines, and it is not improbable that a stampede of considerable proportions may take place towards that camp in a short time." The *Courier* article stated that "in our opinion there is no

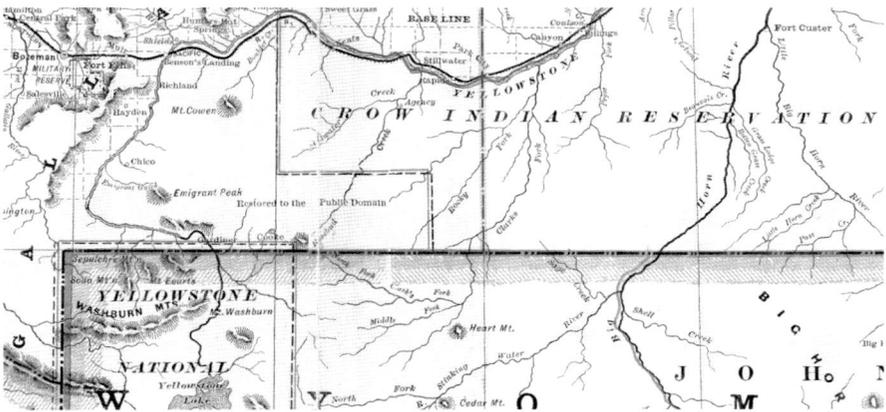

Montana Territory map dated 1882; note the land "Restored to the Public Domain" just above the township of "Cooke." This map was created just after the Crow Treaty was ratified. *Archives and Special Collections, Mansfield Library, University of Montana.*

doubt as to the richness of mines there, but people should remember that the discoveries so far are at the very high altitudes; that snow is encountered not only at the mines, but on the way there, until late in the spring; that there is no wagon road to the mines, and that there are neither provisions nor tools for sale in the camp." The article said the camp was inaccessible to packing supplies "before the first of June" and that "located as they are, the development of the mines, no matter how rich they may be, will require considerable time and capital."[46]

Despite this accurate description of transportation conditions, which were an impediment to major development, the *New North-West* noted that the "Clark's Fork country expects 1,000 stampeders the coming summer."[47] Speculations of the mineral wealth in the area had spread across Montana Territory and coupled with the promise of big-time investors. In the not-so-distant past, Jay Cooke had expressed interest in the mines, so, surely, names such as his would rise again.

Things progressed quickly, as miners who had long awaited this development began making the improvements necessary to effectively reach the camp, as reported by the *Helena Weekly Herald* of April 27. The paper wrote that "parties interested in Clark's Fork mining property, to the number of thirty persons or more, have entered into an agreement to construct a wagon road from Baronett's bridge, Yellowstone valley, to the mines this season." According to the article, it was believed that "with the force already secured the road can be built in a month to six weeks."[48] This would be just in time for development work to commence on the mines in the early parts of June.

On May 20, 1882, the building of a road was first attempted by thirty-year-old Jack Allen, who, after a year of "city life," had decided to leave Bozeman for the Clarks Fork mines. Allen had been born in Illinois but spent most of his life pushing west—first to Deadwood, South Dakota, then the Black Hills, before making his way to Montana territory. Newspaper accounts would later say that he "left the Black Hills country on July 1, 1881." The following day, President Garfield was shot; Allen would not hear the news until he arrived in Bozeman six days later.[49] The *Carbon County News* published an article about Allen in 1934 that mentioned his experience blazing that first road through the national park: "May 20, 1882, he, in company with Harry Sweeney, hitched a four-horse team to a mountain wagon and started the trek to the then almost unknown country now designated as the New World mining district…after seventeen days, arrival was made in the place which has since been the home of Mr. Allen."[50] At the

date of the article's publication in 1934, Allen was eighty-two years of age; he would live another ten years.

When newspapers reported on the mines, they nearly always described Cooke City's location as being "about three miles from the park," which must have made for a curious reader. Such attention to proximity created a loaded sentence fragment. Those who wrote about Cooke City in the coming years played heavily into Jay Cooke's involvement, although his ties to the area had come and gone. No matter how optimistic an article may appear today, one sees the park's mention as a shadow over development of the mines. A *Billings Herald* article exemplifies this concept. The article noted that there were at least "500 prospectors and miners scattered over the Clark's Fork district" in the summer of 1882, and that "Crook City [*sic*], the central camp" had grown "from nothing to a town of 100 cabins." (Note the restyling of Cooke City into "Crook City.") It stated that "the whole district is almost one entire body of mineral," which contained mainly silver but carried a good proportion of gold. The paper reported operations on the Great Republic and falsely stated that the mine had been "sold by the discoverers for $60,000 to a Philadelphia company headed by Jay Cooke." (The mine had only ever been bonded to the company; a sale had never been consummated.) In brash optimism, the article states, "there can be no doubt but what the coming season will witness, in the Clark's Fork district, an outbreak of mining activity which has not had its equal in Montana since the earliest history." The article concluded that the camp was "about three miles from the Park."[51] It was this last statement that would haunt the camp in the years to come.

The location of Cooke City on a climate map also played heavily into mining operations. Setting the park issues aside, the mines were under snow for more than half of the year. Many of the miners left the area during the winter months, although production by no means completely ceased. On May 11, 1883, the *New North-West* reported that a "traveling agent of the Northern Pacific, came up the road a few days ago with 150 Michigan miners who are headed for the Clarke's Fork mines, and 250 were expected on the 8th for the same point."[52] However, a paper dated July 11 counts only 75 men in the camp, although there were 135 houses, and notes: "the buildings will all be occupied by their various owners in about two weeks time, and would have been ere this were it not for the snow. One cannot get upon the mountains yet."[53] While many of the Michigan miners may have been living in the surrounding mountains, it is unclear why they would have headed into the area if the snow had been on the ground in July. There is

also the probability that many of the incoming miners were located some distance from Cooke City in the Clarks Fork district and therefore wouldn't have been noticed in the camp itself.

There Is Now Prosperity for All

For every comment against the feasibility of mining at Cooke lay one in promotion of its rich mineral resources. These resources were highlighted when the Clarks Fork mines were included in *Montana, its Climate, Industries and Resources*, an 1885 publication created by the Commissioners for the World's Industrial and Cotton Exposition. The writing was factual and straight to the point, giving notice of the developmental work that had been done and acknowledging the issues of transportation to ensure a prosperous outcome. The article stated that the mineral district was of "vast extent" and that it had been "prospected over a length of nearly fifteen miles, with a varying breadth of from one to three miles." This area was continually expanding as rich new claims were made on ground that had not yet been prospected.

It was noted that while the character of the ore varied from "free-milling ore to the most refractory galena," and the locations made were "almost numberless," most of the claims were not developed beyond what was "required for the purposes of representation." This was due, in large part, to the lack of transportation, although the district did have two smelters—a fifty-ton smelter owned by the Great Republic Mining Company and a smaller twenty-ton smelter owned by the Wells Mining Company. The description of the district ended as such: "Spoken of but little in the public press and remote from the track of travel, Clarke's Fork in the past has been practically unknown to the class whose attention would conduce to its prosperity."[54] While a lack of capital would be a problem, the real underlying cause of that lack remained the location being so far away from transportation, which seemed to dominate the issues that plagued the camp.

This "vast extent" of district "spoken of but little in the public press and remote from the track of travel" was about to become a national topic of discussion in the coming years at the expense of remaining remote. For those living in 1885, however, optimism was high in the district. In mid-November of that year, the *Livingston Enterprise* reported that "the first load of coke for the Republic smelter" had reached Cooke City, and that "Geo. Armboldt wants to be put on record as the man who hauled it." The article went on to announce

Principal Mines in the New World Mining District, 1908. Over three thousand claims had been located in the district, but only three hundred were noted on this map. *Cooke City Montana Museum.*

that "the long looked for smelter of Gassert & Redding reached Cinnabar Thursday by Park branch train where teams had been waiting for ten days or more to transport it to Cooke. It was immediately transferred from the cars to wagons, and is now moving toward the camp, where it is hoped it will be in active operation in two weeks time at most." The article concluded "There is a feeling of good cheer in the camp and well there may be. There

is now prosperity for all—a home market for all ore that mine owners may wish to sell, and employment for all who choose to labor."[55] Elsewhere in the newspaper, it was announced that a final meeting would be held for those committees working in the interest of the Cooke City railroad project.

Such optimism on the side of the prospects was evident in the mining activity that occurred throughout the winter. Reports as early as January 1886 talked about "unusual activity" for the season.[56] The smelter on its way from Cinnabar was a "five-ton, steel-lined, water jacket smelter, designed mostly as a prospect mill and as a test for that particular make of smelters"[57] that would be discarded by January of the new year, 1886, and replaced by an existing smelter in the area. By March, Gassert had ordered a "fifty-ton Hartfeld smelter" following a rich ore vein strike in January.

Meanwhile, the Great Republic smelter was extremely active in January 1886. The *Livingston Enterprise* reported: "the Cinnabar and Cooke Transportation company, with H.J. Hoppe as manager, have completed a contract with the Republic mining company going into effect after the first of January, to deliver at the smelter thirty tons of ore daily from the mines; also to transport weekly thirty tons of coke from Cinnabar to Cooke, and the same amount of bullion from Cooke to Cinnabar."[58] A warehouse was also built in Cinnabar to accommodate the company's needs. In February, it was noted that the company would "blow their whistle three times a day,"[59] and by March, the smelter had been shut down due to an exhaustion of coke supplies with plans to commence once it had been restocked.[60] By the summer of 1887, it would be reported in the *Philipsburg Mail* that the Shoo Fly mine "had had one thousand tons of ore worked in the Republic smelter that have netted $25,000." The Shoo Fly mine had been one of the first discoveries in the camp by pioneer Horn Miller and his partner J.H. "Pike" Moore. In time, a legend would emerge about the townsite of Cooke City once being called "Shoo Fly"—however, there is no mention of that name in any of the contemporary newspaper articles.

GOT SOME "BOOT" IN THE DEAL

By November 1882, the citizens of Cooke had become interested in having a government survey of the townsite completed so they could lay claim to their lots. The *River Press* noted that the survey included "640 acres for a townsite" at this "metropolis of the Clark's Fork Mines."[61]

The citizens of the new township of Cooke City also made their presence known in the first election in which they could participate. The *River Press* noted the occasion: "the mining town of Cooke city cast 227 votes at the late election for delegates to the constitutional convention, a large majority of which were republican votes, securing the election of two delegates from Gallatin county—Eaton and Pease."[62] Major Pease not only had mining interests in the area but also worked as a government Indian agent at the Crow Reservation and was present at the naming of Cooke City, while the Eaton brothers were prominent in Cooke City mining.

George and Charles Eaton were born in Maine and had made their way west by the 1880s.[63] George took an interest in mining following his resignation from the army, and both Charles and he would find their places in politics—in particular, those of Montana Territory. In 1884, the *River Press* printed a note about George Eaton being in consideration to be sent as a delegate to a Chicago convention. The paper stated: "Mr. Eaton, without regard to his presidential preferences, would certainly fill the bill. He was a member of the constitutional convention, and besides being a gentleman of ability was pronounced the handsomest man in that distinguished body."[64] Besides his handsome looks, George had the backing of the Cooke City community. In 1882, he had organized the Great Republic Mining Company and built a new smelter in the area. As if that wasn't enough, the large, two-story mansion at the end of town all but shouted that these brothers were indeed invested in the town. While their political lives would eventually pull them away from Cooke City, from the early 1880s until about 1910, their influence in the mining camp would be a great part of its history.

Early articles in 1884 gave more information about the look of the town and the buildings and businesses present. Whether or not it was intentional, these articles gave potential investors the sense of a booming town and, hence, a booming mining industry, even if seven saloons in a town of less than three hundred people seemed excessive; as the *Mineral Argus* noted, there were also two grocery stores and five boardinghouses.[65] The establishment of a bank in March 1884 must have strengthened that booming image. The *New North-West* announced: "the Cooke bank has been established at Cooke City, Gallatin county. D.E. Fogerty President; D.H. Budlong, Cashier."[66] There are only two known instances in which the Cooke Bank was mentioned in newspaper articles; the first proclaimed its establishment, and the second, printed in the *River Press* on June 25, 1884, humorously reports on its grand opening: "The new banking house at Cooke city was opened one evening last week with a dance, which was broken up by a general fight growing

out of some trifling matter. When the fight was ended the sheriff had one prisoner and ten revolvers, but several individuals, including the deputy sheriff, were next day arrested and fined."[67]

Such prompt law enforcement was not typical in the young camp. The celebration—or maybe the mere introduction of such an institution as a bank—must have encouraged the extra security. Either way, it seems there was no authority beyond the discretion of the miners the year before in February 1884, when the *River Press* reported that

> *Drummond, proprietor of a boarding house at Cooke City, became violently jealous of his wife because she danced with another man, and taking her outdoors into the snow, choked her and threatened to kill her. The miners of the district heard of the racket and took the jealous husband into custody, and next morning marched him out of camp with some forcible remarks about what might happen to him if he ventured to return.*[68]

While it is uncertain which boardinghouse (of the five or more in town at the time) was owned by Drummond, there are two buildings worth mentioning.

Following his arrival in 1882, John or Jack (J.P.) Allen began to build his Allen Hotel, which opened its doors in 1884 and soon became known as the Cosmopolitan. The white, two-story hotel quickly became a fixture in the town, anchoring the western end like a bookend to the Eaton residence. It was said it could accommodate 150 guests per day, and they would "always receive polite attention."[69] Allen dabbled in mining affairs—mainly buying and trading mining claims for Cooke property—and, in one instance, said: "I remember in 1889 I needed a watch, so I traded a mine for one. Oh, yes, I got some 'boot' in the deal."[70] But his main concern was his hotel, which remained standing well into the mid-1900s.

Across the street, another boardinghouse was built about a decade after the Cosmopolitan, although it was considerably smaller. The proprietor, John Curl, had arrived in Cooke City in the 1880s with mining prospects in mind. He often partnered with Horn Miller and George Huston, both early founders of the community, in his mine holdings. Miller would come to winter with the Curls and was remembered fondly by Mary Margaret Curl, one of the few children to grow up in the mining camp, although children were by no means completely absent. On December 12, 1883, the *River Press* reported that "the new mining camp of Clarke's Fork, is bound to be a productive district at an early date, judging from its first output of bullion,

Mr. and Mrs. Jack Allen in front of their Cosmopolitan Hotel. *Cooke City Montana Museum.*

which was a girl baby, born of the 20th of last month, the mother being only twelve years and one month old."[71]

As it so often does, news out of Cooke City rarely included a follow-up article except in the cases of major events, drawn-out discussions on politics and stories of life or death. Nothing more can be found about Julia Foster, the twelve- to thirteen-year-old girl who had given birth, but the birth notice was included in at least four different newspapers, including one out of Missouri. The *Avant Courier* included a note about the father, who had reportedly "skipped to parts unknown."[72] The reading audience of yesteryear was little different than that of today; they were intrigued by a scandalous story.

A THOROUGHLY WESTERN STYLE

In 1885, two incidents worth mentioning occurred in Cooke City. In August, a high-stakes cribbage game played in Cooke City was reported in five newspapers, including two in Minnesota and one in North Dakota. The romance of gambling and mining made this story an oft-retold verification of Cooke City's status among colorful mining camps. The *River Press* reported on September 2, 1885, that "a highly exciting cribbage match was played at Cooke city on August 14. The stakes were 100 feet of the Snowslide against 100 feet of the Elevator lode—both rich properties. The conditions were that 100 games of cribbage were to be played, the man winning the most games to take the stakes. The game began about 3 p.m. and ended about 3 a.m. with the Elevator man ahead and winner. The deeds to the 100 feet of the Snowslide were made out and given him and he was immediately offered $1,500 for them."[73]

In late September, the effect of having seven saloons in a small town showed itself when a report in the *Daily Yellowstone Journal* stated: "Daniel Brant, of Cooke City, while intoxicated on Saturday night, lit a stick of giant powder and while engaged in swinging it in the air had his right hand blown off. A messenger was dispatched for Dr. Alton, of Livingston, who went up at once."[74] On today's roads, it is 110 miles (or two and a half hours) from Livingston to Cooke City. It was said of Dr. Alton that he was "one of the grandest and most accomplished gentlemen Livingston ever knew or will know" concluding "it was a hard task in those days to drive with team and buggy to Cooke City…especially in 40 below weather; but Dr. Alton drove it."[75] When Alton first arrived in Livingston, he stayed at the Nolan

Hotel, where J.P. Allen was, at that time, a cook. In 1886, he attended to the ailing George Huston,[76] but to no avail. At the age of forty-two, Huston succumbed to typhoid pneumonia, and Cooke lost its first pioneer. As with Dr. Alton, those who knew Huston spoke highly of his character. A report in the *Livingston Enterprise* stated that "many of his companions in the mining industry will be bowed down in grief over the departure of such a beloved and trusted mate," and added, "he was led greatly by impulse and would starve himself before he would see anyone else want. He made money easily and spent it freely and generously in a thoroughly western style."[77]

In March 1887, it looked like mischief was again afoot in Cooke City. Much like the tale about Mr. Smythe and the fake tunnel of 1880, a new scheme had been developed to make a local profit at the expense of a visitor looking for an investment. That spring, snow was reported at ten feet "on the level, if there is any level."[78] The *Billings Gazette* gave a warning, reprinted in two different newspapers, that "some dishonest citizens" had recently "taken advantage of the deep snow to perpetrate a disgraceful swindle on arriving speculators." The article explained how the deed was done: "The swindler gets a length of stovepipe, and sticks it up in the snow over the nearest vacant ground to the business center. He informs the spectator that he has a house under the stovepipe, and sells the house and lot for what appears to be very reasonable figures." The swindler wasted no time with his scheme, however, making "several such sales in the shortest possible time" before skipping out to "enjoy his ill-gotten gains where the law cannot reach him."[79] Again, stories of humor seemed to balance out what could be an extremely harsh environment. Many incidents would occur in those early years.

In November 1883, the *River Press* reported the death of Chancey Butler, "a teamster at Eaton's saw mill" who was "killed instantly by a falling tree."[80] The sawmill was a relatively new addition to the camp and was used by the Republic Mining Company under the guidance of George Eaton. Life in the mountains was risky, and the population increase made instances of this nature more common.

A story of life or death occurred in 1884, when a replacement carrier working on the mail route to Cooke City became lost in a snowstorm. According to the *New North-West*, J.S. Anderson, "being anxious to visit Cooke City," had taken the place of the regular carrier, who had taken ill. Anderson had started out "with pony and toboggan to make the trip through the deep snows and over a rough mountain country, where the trail is not easily followed by an unaccustomed traveler even in summer." It is unknown to what level Anderson knew the landscape, particularly the winter

landscape. Upon reaching the Blacktail divide (about eighteen miles from Mammoth in the Park), he "lost his way" and seemed to have "wandered about for a long while, perhaps nearly a day, until worn out with fatigue and benumbed with cold he sank down overcome with the sleep which is generally a fatal feature in such cases." Luckily, he awoke, and finding "that his feet and the lower part of his legs were frozen, and that his hands were badly frostbitten," he "abandoned his pony, left the mail where it might be found and started to drag his frozen limbs in the direction of Mammoth Hot Springs." He had been out for two days and two nights, and as a result, it was believed that "the unfortunate man will very likely lose both his feet, beside undergoing an unutterable amount of suffering."[81] However, an update by the *Rocky Mountain Husbandman* claimed that Anderson "is getting along nicely and will probably not lose his feet."[82]

The mail route would long be a subject of contention among the residents of Cooke City—particularly mine owners, who depended on the mail for business dealings. It was an issue of distance and man versus nature, and it was not to be taken lightly, as the unfortunate J.S. Anderson learned the hard way. Even those who were familiar with the route endured hardships, as indicated in an article commending mailman David Dobson for his efforts in carrying the "Cooke City mail all winter without missing a service. He has snow-shoed over 2,000 miles. He has been snow-blind, lame in one leg, had his nose frozen, lost overshoes and gloves repeatedly; but in spite of all that he never fails to deliver the mail."[83]

Receiving mail in the winter was a necessity, as more and more mining companies continued work despite the snow. Mining in the winter, while productive, did have major drawbacks, and at times, such activity resulted in fatal consequences. On New Year's Day in 1887, two miners—Toney Wise and Edward Martin—lost their lives in an avalanche that buried them under fifty feet of snow. On January 15, the *Livingston Enterprise* included notes on these men and a more detailed description of the accident, stating that the two men had been employed by the Republic company. The article described the events that led up to the deaths: "On New Year's Day a small slide occurred near where they were working which covered up the mouth of the tunnel. An opening was made in the snow to permit the men to get out, and it was arranged that two of the party should work on the outside in removing the snow from the mouth of the tunnel." Wise and Martin were the two men who commenced the work—against the warnings of the foreman, Nick Tredennick. It was at the moment when the latter was coming to tell the men to stop work for the day when the fatal avalanche

Gate to the Cooke City Cemetery. *Author's collection.*

occurred. The article stated that Tredennick "had proceeded but a short distance when he saw a second slide coming, which carried him about seventy-five feet, where he caught the limb of a tree, to which he held and thus saved himself from certain death." Wise and Martin "were carried down the mountain nearly a mile" and buried so deeply that it would be "impossible to recover their bodies before the snow disappears" in the summer. According to the paper, the slide was "said to be the biggest that ever occurred in that vicinity, being one half mile wide." Wise, a twenty-six-year-old from Eagle River, Michigan, had been employed by the Northern Pacific before beginning work in Cooke City only two years prior to the accident. He had spent considerable time in Livingston on his way to Cooke City and was said to be "a man of good habits, industrious, and was respected by all who knew him."[84] It wasn't until July that the bodies of the two men were found and buried in the local cemetery.

The risk of mining was not limited to bodily harm; there was also a huge financial risk in involving one's interests in the mines. As such, men located at the camp did their best to promote the bright outlook of the town and the mines through the newspapers whenever possible, balancing out the risks with the integrity and ingenuity of the people who lived and worked there.

4

THE BATTLE FOR A RAILROAD

THIS LOOKS LIKE A LIVELY CORPSE

News came back around to the major topics of mining and the issues of a railroad at the close of the year in 1885, as it seems is the case in most years. With mining work on hiatus for the winter, the men would focus their energy on railroad matters. Congressman John Joseph O'Neill of Missouri was adamant in his appeal to the nation to prevent railroad passage through Yellowstone to the Clarks Fork Mines and was quoted in the *Great Falls Tribune* as saying: "This nation has got only one park, and I want to see it let alone. There is a little block of land fifty-five or sixty miles in size, all that Uncle Sam has retained for the enjoyment of the public, and you folks can't keep your hands off that!"[85]

This "little block" did, indeed, literally block the miners of Cooke City from access to a railroad. The best route would follow the Soda Butte Creek through the northern portion of the park. Early attempts to grant access through the park had stalled despite strong support by locals, including the editors of the *Livingston Enterprise*, who, in December 1884, voiced their opinion that "the 'right of way' seems to be the only hitch…this is a mere question of time. The proposed extension will in no way interfere with the rights or desirable privileges of the Yellowstone National Park, and we can see no reason why the 'right of way' should not at once be accorded to the company that desires to avail itself of it."[86] By October 1885, the

Map of the Northern Pacific Railroad and connections, 1885. Note the Clarks Fork Mines that lie within the railway's holdings and the spur line connecting to Cinnabar. *Archives and Special Collections, Mansfield Library, University of Montana.*

surveyor general of Montana, General J.S. Harris, had paid a visit to the mining camp, and his opinion on the prospects was quoted in the *Livingston Enterprise*. He strongly supported the Cinnabar (where the Northern Pacific terminated)-to-Cooke route following the Yellowstone River and Soda Butte Creek. A simple but publicly prominent map printed in the 1892 *Bozeman Directory* showed this route. Having carefully looked over the route, Harris believed that "except the ten miles above Gardiner it is very easy" and that he "should estimate the cost of construction and equipment of such a road

at about three-quarters of a million—certainly inside of a million." While in Cooke City, Harris attended a railroad meeting where the alternate Clarks Fork route was discussed and shot down. Harris reported "from all the information I can gather on the subject it would cost as much to build twenty miles of the Clarke's [*sic*] Fork road as it would to build the entire connection from Cinnabar to the district. And I understand beside that it would be very difficult to keep the former road open in winter and spring."[87]

Despite support for the direct route, in late 1885, an alternate plan was drawn up to segregate the portion of the park necessary for railroad transportation—a scheme which, again, was met with strong opposition. These two seemingly related plans became incompatible, dividing the would-be supporters of a railroad to Cooke City into two separate camps; eventually, such division allowed them to be conquered by those who wished to block any railroad through the park. Also, the proposed route from Billings through the Clarks Fork area was an idea that would not die easily. It would bury itself in the back of legislative minds as a viable option, although in reality, it was merely a pipe dream. There were those who knew the land and had faith in the value of their prospects, such as the miners and their supporters, and then there were those who saw the request for transportation as a dent in their wilderness. For most, there were undeniable advantages to the progression of the railroad, particularly in the outlying cities of Livingston and Billings. Both lay equidistant from the rich mines of Cooke City, and both wanted a piece of the profits and prestige that would come with being the outlet. To access Livingston, the railroad would have to traverse the northern section of Yellowstone National Park through to Cinnabar and the Northern Pacific Railroad. This outlet had already caused years of national dispute but seemed to offer a lesser evil than turning attention toward Billings and the costly investment of running a rail up the Clarks Fork. This situation pitted city against city in an all-out war of wits. In 1887, the latter plan up the Clarks Fork was wrapped up in land rights issues. The proposed route was to go through Crow reservation land. In January 1887, the bill that would grant a right of way through the reservation to the Billings, Clarke's Fork and Cooke City Railroad seemed to be destined to happen. It was reported by the *New North-West* that "Billings is happy, and wears an I-told-you-so expression."[88] The battle over Cooke City had begun.

On January 28, 1888, the *Livingston Enterprise* reported that "one of the mine owners of Cooke City, came down from that camp the first of the week. He states that about twenty miners are wintering there, and all are hopeful that the coming season will supply the long-needed transportation

to the mines of that district."[89] This optimism would be tested in February, when the Clarks Fork route ran into one uncomfortable situation after another. While most miners did support the Yellowstone route, they no doubt kept a keen eye on the developments coming from Billings. A railroad was an outlet, regardless of its direction. In mid-February, the U.S. General Land Office had discovered that the newly named Rocky Fork & Cooke City Railroad Company (the company working on the Billings, Clarks Fork and Cooke City Railroad) had not filed a "map of its definite location," and as such, "all timber-cutting done by the company or its agents is unlawful."[90] As punishment, "$70,000 worth of bridge timber, pilling etc." was "tied up"—a situation that led to the next problem for the railroad company. A week later, it was reported that "the laborers, who quit work sometime since because no pay was forthcoming, were starving and houseless, and were finally by order of the Board of County Commissioners fed and lodged at the county's expense. This was at last stopped and now the workmen are again without the means of supporting life and rioting is daily feared….The railroad company is heavily in debt to the merchants of Billings."[91] At the same time, it was noted that the General Land Office had made a mistake, the correct papers had been filed and "the seizure of the company's lumber was simply an official blunder, which coming at just the time it did, when the company was otherwise harassed and embarrassed was inexcusable."[92] The correction by no means rectified the situation for the company, and no sooner had the *Philipsburg Mail* of Philipsburg, Montana, published the above than a new situation arose. On March 1, the paper reported that "as a further complication of the Rocky Fork muddle it is now charged that certain Crow Indians have been influenced to sign a petition that the Billings, Clarke's Fork and Cooke City right of way bill will be defeated."[93] This complication was short-lived, however; by April 4, the bill had passed the U.S. Senate, with the *River Press* reporting "this looks like a lively corpse,"[94] and in May, it passed the U.S. House.

The *Livingston Enterprise* had started early in its criticism of the Billings route, responding to a comment made in the *Pioneer Press* by a Butte correspondent stating that the only viable route to the mines was by way of the Clarks Fork. The *Enterprise* retorted: "the writer of the article either exhibits gross ignorance of the matter of which he treats or a reckless disregard of facts in making such statement. The proposed course of the Clark's Fork road lies through the Clark's Fork canyon,--a route that Engineer Gallagher, who made a partial survey of it two years ago, is credited with saying was better adapted for natural scenery than a natural railway grade."[95] By May, the

Enterprise was butting heads with the *Billings Gazette*, dramatically noting the difficulties a rail would have in coming up the Clarks Fork, as it would include "tunneling a high range of mountains," while calling out falsehoods in the Billings plan, saying "if the gazette will confine itself to truth in future no objection will be offered to it in the pleasing diversion of building paper railroads."[96] When the railroad bill passed the house, the *Enterprise* claimed: "No one believes that the Billings, Clark's Fork & Cooke City road will be built further than Rock Creek,"[97] where a large coal deposit had been discovered. Many assumed the bill that had been purported to be a rescue mission for the Cooke City mines was in truth only a front for those interested in the coal mines, and it had never been intended to be built further than that location. The real story lies buried between the lines of articles and meeting notes; in any event, the railroad never came any closer to Cooke City from that route.

The railroad issue continued to plague the mining camp throughout the year despite optimistic claims that a railroad was soon to come. The *Livingston Enterprise* continued to fervently promote the Yellowstone route, condemning the Billings plan as impractical. When the *Billings Gazette* claimed that the miners would prefer the route over the Clarks Fork, the citizens of Cooke City began to raise their voices as well. On April 6, 1889, the *Livingston Enterprise* printed a direct response—from some unknown man or group of men living in the camp—to the *Gazette* writer anonymously named "Quartz." The letter stated the sentiments of the miners: "The question of how to overcome excessive freight rates has with us, been a serious one. It cannot be denied that the development and subsequent progress of Cooke has in consequence been unjustly retarded; so much so in fact, it is becoming a matter of general regret, that our products cannot go to help swell the grand total of the output of the territory." The miners had, of course, been interested in a decent wagon road to help relieve some of this pressure. While the freight rates would still have been quite high, such an improvement would have provided some assistance to the miners in their endeavors. However, as pointed out by the author of the letter, "While a good wagon road would in a measure overcome present conditions, the necessary expenditure to put in repair the one we now have, would be too great a burden for our citizens alone." In response to Quartz's implications in regards to the national park, the author wrote: "It is true, as 'Quartz' implies, the Park has always been to our detriment, though happily not through its direct management." It was the "too scanty appropriations made by congress" that made such improvements to the road a near impossibility on the government's end. Quartz had chosen a wagon road by way of the Clarks Fork through to Billings as a means of

relief; however, as no such road currently existed, the expense of creating one would have exceeded the expense of improving the park route. The distance may have been longer on this route, too, raising freight fees. It seems that the miners of Cooke City had held some hope in the Rocky Fork Railroad and Billings, Clark's Fork & Cooke City Railway schemes, "as the one of the other of these roads advanced (on paper) it was but natural that among anxious citizens, some could be found who credited the projectors of these schemes with absolute good faith." Still, the general consensus lay in their terminus at the coal mines outside of Red Lodge with no intention of proceeding further toward Cooke City. The author of the letter concluded: "Not withstanding the almost numberless obstacles with which to contend, the popular belief has been that when the railroad came it would be by none other than the Cinnabar route," and that with "a branch at Livingston assured, and the hither to bitter opposition of congress to segregating a narrow strip from the park gradually giving way the problem which has so long confronted us, is practically solved."[98] The author of this letter shows an important fact of life for the miners—while they did support one line over the other, none among them would completely denounce a plan that would be to their benefit. However, the "problem" would last longer than they could have imagined. In fact, it would be unsolvable.

Cooke City's Future Was Never Brighter Than Now

Despite the lack of a railroad, Cooke City continued to attract miners, investors and politicians alike. The late 1880s and early 1890s saw the town in a boom. A late August 1889 letter to the *Livingston Enterprise* was signed "B." and stated: "There are probably more prospectors in the camp this year than ever before" who all hoped to "see the dirt flying in the early spring"[99] to mark the advent of a railroad. It was words rather than dirt, however, that would fly throughout the next few years. In June 1889, it was reported that Mr. Villard of the Northern Pacific planned to make a visit to the national park, presumably making a stop at Cooke City to view the mines. The report claimed that "with a thorough understanding of the vast business that would accrue to the Northern Pacific by the extension of the Park branch to that camp, through its consequent rapid development, there is little doubt that all the powers of his aggressive policy will be brought to bear in accomplishing

that result."[100] On July 6, the *Enterprise* reported that an official of the Northern Pacific had toured the mines, as told by the hopeful guide Jas W. Ponsford. It was noted that "Jim is in the best spirits, being sure the Northern Pacific intends to build to Cooke as soon as right of way can be secured, and feeling sure, also, that he has parties 'on the string' who will take some of the valuable properties in the camp of which he has the disposition."[101] This is the kind of hope that fed the miners of Cooke City.

By the summer of 1888, local newspapers were abuzz over several large mining deals in Cooke City. In June, the *Enterprise* concluded: "The outlook for Cooke City's future was never brighter than now, and with the influx of capital that will result from the purchase of these mines the problem of cheaper transportation for the camp will be solved and its prosperity be assured."[102] Land in Cooke City was selling at high prices; in March, two lots had sold for $500, which, according to the *Bozeman Chronicle*, was "an impetus being given it by the almost certain construction of a railroad to that point next summer."[103]

On June 5, 1888, Colonel David Noble of Cooke City traveled to Livingston, "bringing with him fine specimens of ore from the Tiger,

Cooke City from Miller Road. The Cooke City Store and Yellowstone Tavern are opposite each other in the center of the image, the Cosmopolitan Hotel is at the right edge of the road and the Republic Smelter is visible at the base of Republic Mountain. *Cooke City Montana Museum.*

Morning Star, Alice E., Mount View and Treadwell lodes."[104] His life would resemble the lives of many a Cooke City miner. A year later, the *Enterprise* reported that "word comes from St. Paul that Col. David Noble has recently sold a mining claim in Cooke for $7,000. He is at present a guest of the Ryan hotel, sports a swallow-tailed coat, silk [tie] and picadilla collar."[105] By 1896, the *Anaconda Standard* was describing Noble as "one of the prominent mining men of Montana and a well-known mining expert," mentioning Noble's twenty-five years of mining experience and his ownership of many of the best mines in Cooke.[106] Twenty-seven years later, in 1923, the *Big Timber Pioneer* would paint a different picture of this magnanimous man:

> *An old fedora hat showed signs of contact with many a Livingston wind, a gold nugget stick pin assisted in holding a worn and faded tie intact, a tricolored vest kept company with a coat worn shiny by the ravages of time, while a pair of checkered trousers, hanging at half mast and baggy at the knees, loitered above a pair of desolate looking shoes that had not experienced a blacking brush for many moons. A bystander remarked: "That old fellow is from Montana, and he is lousy with money." And possibly without sufficient in his pocket to buy a square meal, the Colonel [David Noble] felt what the stranger believed. He was rich, in his own mind. He had wealth untold lying buried in the hills of the New World mining district. It might not be until tomorrow, possibly not until the day after, or maybe the next week or month, but as sure as the sun rose and set a railway would be constructed into Cooke and the remainder of his days would be spent in ease and contentment.*[107]

Noble would fade, like many of the miners who put their future in the mines of Cooke City, but also like many, he would remain faithful to the camp until his death.

In the winter of 1888–89, there were forty men at work in the mines of Cooke City with excellent prospects in sight.[108] As if the mineral wealth at Cooke was not enough to promote a railroad through the park, the *Miles City Journal* came up with another reason, claiming that "the Soda Butte waters of that vicinity will become valuable property. These waters are especially valuable to consumptive patients. A gentleman says that at one time he was spitting blood, when he went to the spring and drank the water three days, procuring a number of bottles which he filled in such a manner as to keep out of the air, and that his recovery was entirely due, he thinks, to the medicinal qualities of the water."[109] This discovery, however, did not interest investors

and didn't seem to have a following beyond these few printed words. Soon after this published claim, a correspondent from the *Gazette* reported that "some two miles up the creek, from a point where it is intersected by the railroad, according to the preliminary survey made by Mr. Gallaher in the spring of 1886, there has been discovered a large deposit of very fine marble by Robert Mandeville and William Chick two miners and prospectors." Investors sent one thousand pounds of the marble to New York for testing, where is was "pronounced on all hands to be equal if not superior to the best Italian marble imported, worth $130 per ton for small dimension pieces such as mantles, tomb stones and house ornamentation. They will do some considerable work on the quarries this summer, open up etc. But of course, it must lie dormant until the arrival of cheap transportation for moving it."[110] It would appear that such transportation concerns again stunted the development of the enterprise. Robert Mandeville remained a miner at Cooke City until his death and was buried in the local cemetery. William Chick was killed in a shootout within a few years.

In March 1889, the *Livingston Enterprise* again reported a boom in Cooke City property rates, stating that "a large amount of mining property is changing hands and a number of organizations are under way for the development of good properties in that neighborhood," and that they knew of "several parties who have refused good offers for lots in that coming town."[111] Thomas Blackhart, from Louisville, Kentucky, was one of the lucky buyers, becoming part owner of the Alice E. mine. His arrival in March 1889 was recorded by the *Bozeman Chronicle* along with his opinion of the camp and his conclusion that "a lack of money is all that has handicapped the camp and that this drawback would be removed during the summer."[112] The *Philipsburg Mail* related that the gold-bearing Alice E. had been purchased for $27,500, which would be equal to over $700,000 today.[113] Blackhart was not alone in his assumption that money would cure Cooke City's chronic illness; many investors would try the same tactic only to find that the dollar had stiff competition in the wilderness.

The World Has Never Seen the Equal of This People

As 1889 drew to a close, a new voice chimed in on the railroad issue—that of Professor G.C. Swallow. In his role as territorial mine inspector of Montana,

Swallow spent two weeks in late September or early October 1889 at the New World Mining district looking over the properties for his annual report. It was said that "Mr. Swallow is favorably impressed with the extent and richness of the deposits of the New World district, and as his position as professor of mineralogy in the State university of Missouri, coupled with extensive practical experience in Montana, has rendered him proficient in mining matters, his favorable opinion will prove advantageous to the camp in bringing it to the attention of outside capitalists."[114] The *Helena Independent* printed the first of Swallow's articles on October 29. If Cooke City had ever wanted a spokesman, here he was, in lofty poetic prose, demonstrating the hardships of the miners and the steps that must be taken to rectify the situation. According to Swallow, the miners of Cooke City were akin to the great pioneers pushing west, promoting industry in the wilderness, and there is little written that comes close to his descriptive analysis of them:

> *The people who discovered, developed and hold the mines of this district with a firm belief in their vast wealth, belong to that intelligent and vigorous and patriotic portion of Americans who have finished up the states of the Atlantic slope, made those of the Mississippi valley and are now laying broad and deep the foundations of the great commonwealths of the Pacific slope and the Rocky mountains. The world has never seen the equal of this people. Ten thousand times more efficient than an army with banners have been these bands of workingmen and workingwomen, in their quiet but never wavering march from the Alleghenies to the Pacific, taking with them their household goods, their plows, their picks and shovels, their schools and their churches. Before this grand march of the pioneers carrying westward the empire, the savages retreated and slunk back into their peaceful reservations; behind it sprang up farms which feed the world, cities and railroads, what they call civilization: and from it poured out the streams of gold and silver and copper and lead which have vitalized and made permanent the financial condition of the country.*[115]

So began Swallow's plea for justice in the name of the miners of Cooke City, who belonged in the ranks of "men who have made the country." Swallow had his audience hooked by those first paragraphs filled with adventure and a sense of destiny. What better platform upon which to build a strategic discussion of the railroad issue, in particular the route through Yellowstone National Park? Swallow considered the objections to this route "more imaginary than real" and argued for congress to use the Yellowstone River and Soda Butte Creek to

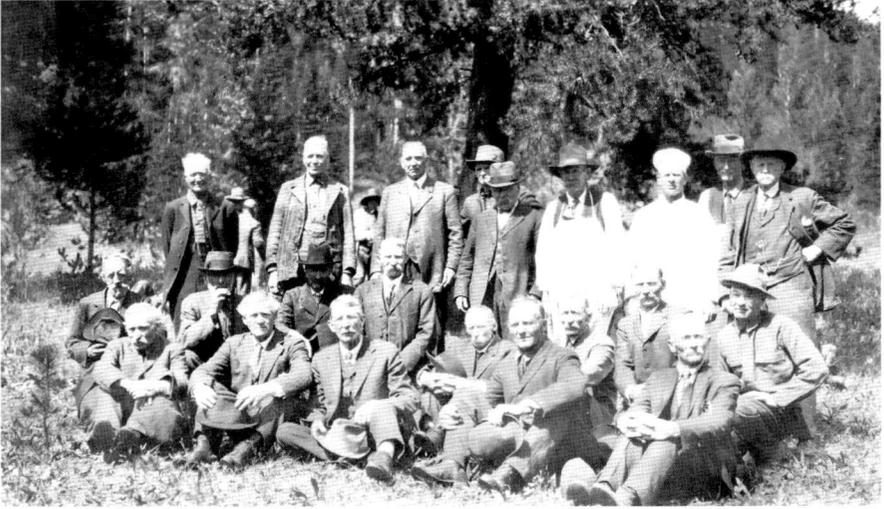

Old-timers at the annual fish fry; Nick Tredennick is seated second from the left in the first row. *Kathy Kleppinger, Tredennick family.*

mark the park boundary, thereby allowing a railway to be constructed on the north side. Swallow claimed that "such a natural boundary between the park and the lively, enterprising people of Montana" must be a well-defined line, otherwise "there will be endless disputes between the American citizen, who thinks his right to bear arms and shoot game should not be questioned and the American soldier, who is detailed to keep the American citizens from shooting and killing game on the park." A visible line like the waterway would be an unquestionable boundary between what was right, and what was wrong—"no need of mistakes and contentions."[116]

Swallow went on to answer the arguments against the railroad and the claims that the symmetry and attractions of the park would be destroyed should that portion of the land be taken away from the public. As always, his responses contained lofty ideals: "the proposed boundaries of the meandering streams must be more beautiful and pleasing to all lovers of natural objects in 'Wonderland' than the stiff, straight line now claimed." In response to the attractions that would be cut off, he centered his discussion around the Soda Butte Cone, making a sarcastic promise that no tourist would miss the opportunity of viewing it within the park:

> *If this Soda Butte is insisted upon as a detriment to a railroad that will put millions and millions in the national treasury, Mr. Fitzgerald, of Gardiner*

will take the contract to move Soda Butte over the proposed line into the Park and thus save to the nation's wonder seekers the inexpressible pleasure of seeing a butte about twenty-five feet high and twenty-five feet diameter of base, which was once deposited by a spring or geyser, now inactive, and which has lost all its attractions by the fact that its original cause has ceased to exist, that men, perhaps goats, have trampled over it till all the original and interesting features have been obliterated—the central vent filled up, and the side next the creek undermined and caved in—the whole will soon follow and there will be but little of Soda butte left for tourists.[117]

Little did Swallow know that nearly 130 years later, the Soda Butte Cone would still be standing and remain an attraction for many a tourist visiting Lamar Valley.[118] However, putting the future aside, during his time, Swallow would no doubt have influenced many a reader to rallying behind the noble efforts of the Cooke City miner and railroad engineer. On November 8, 1889, the next installment of Swallow's analysis was published in the *Helena Independent*; his topic of discussion had been redirected from mining to forestation. The article was subtitled, "Plenty of Water and Vast Areas Covered with Timber for the Mine and Smelter, While the Rest of Montana was Parched, Here were Gushing Streams, The Lesson to be Learned From the Destruction of Forests—How Nature's Reservoirs Are Preserved." Swallow began his discussion by stating, "One of the features of the New World district is its extensive dense forests of pine, fir and spruce, with here and there a patch of aspens, willows or alders…here we have a vast forest region covering an area of some 2,000 square miles, ample to furnish fuel and timber for the thousand mines which will be worked in this region." He then went on to explain how the forests surrounding Cooke City not only provided needed fuel but also how, in the autumn of 1889, "after the driest spring, summer and fall ever known in Montana, the mountains and valleys of this forest region were literally sparkling with cool springs and running streams." He used this example to describe, in three stages, how the forests in the mountains helped to provide water for the lower plains (in scientific terms) before comparing the hillsides of industrious Helena with those of unspoiled Cooke City: "If one would see the difference let him visit Cook[e] City and feast his eyes with the glorious forests and the perennial fountains on every hill side and the sparkling streams in every ravine and valley, and then come back to Helena and see our mountains, once clothed with grand old forests and native reservoirs, but now hideous with blackened stumps and naked soils, dry gravels and pebbly channels, where, before the

axe destroyed our forests and natural reservoirs, springs gushed and streams flowed to quench the thirst of the miner and wash his golden sands."[119]

His position on deforestation seemed set, yet his priority was still to see a railroad bring industry to Cooke City. His writing may be a forewarning about what could come to be if care was not taken to protect the vital resources the district had, or maybe he thought an environmental stance could silence the opposition put forth by the *Forest and Stream* editors. Regardless, his discussion had dramatically shifted away from the railroad issue that Cooke City continued to face. Part three of these published articles brought the focus back to the matter at hand: "It has been shown in these articles that there are at Cooke City and in its immediate neighborhood numerous mines which have yielded and will continue to yield vast quantities of the ores of gold, silver, lead, copper and iron, suitable for smelting....But there is one difficulty in the way of the profitable working of these mines—the great cost of transportation." His argument again turned to the lure of adventure and the duty the American public owed the miner willing to work the earth for the benefit of all: "The discoverers and owners of the Cook[e] City mines belong to the true pioneer class of Americans…[who work] in the face of the most daring hostile tribes, thousands of miles away from the nearest supplies of food and clothing and mining implements and the protection they might need from their government." The danger did not lie exclusively in physical harm; these pioneer miners and associates had "worked our mines" and made "expensive experiments with furnaces and mills," and had done so "when the freight was more than the original cost," all in an effort to learn the best method by which to work the mines. According to Swallow, "These pioneer miners and their helpers, full of enterprise and manhood, and quick to learn, are now masters of the situation at Cooke City" and "believe in their mines and are determined to hold them and wait for the railroads, which alone can give them cheap transportation and make their smelting ores profitable." Swallow summed up their situation as such: "These men have worked out hundreds of tons of gold and silver bullion, but so diluted with lead that the freights exhausted all the profits of working." But he held hope for the camp, a hope that lay in the development of a railroad:

> *When Cooke City has a railroad which will furnish cheap freights she will furnish the bullion to keep trains in constant motion on to eastern markets for the next hundred years. These idle mines and cold furnaces will be aglow with vital energy. A thousand miners will take the ore from a hundred mines, and the furnaces will pour out glowing streams of golden bullion.*[120]

Road through the eastern end of Lamar Valley in Yellowstone National Park. *Cooke City Montana Museum.*

Following this persuasively positive review of the miners, Swallow went on to suggest a plan for the railroad, listing those "wonders" that would or would not be lost should the route of travel be altered. At the end of the list, he concluded that the "grand old mountains will probably stay even should the railroad pass up this valley [Lamar] and give thousands more the privilege of seeing them and the rich mines whose ores will yield golden streams of the precious metals to freight the road and enrich the world."

His final words were a plea for action: "How then can a congressman refrain from so changing the boundaries of the National Park as to let the railroad pass up the Yellowstone and Soda Butte to the great mining camp of Cooke City?"[121] This last article was published in the holiday edition of the *Livingston Enterprise* on December 25, 1889. The *Helena Independent* ran one more article detailing the working of various mines in the district on December 31; whether that information came from Swallow's notes is not determined, but either way, the interest in Cooke City was now at a high.

ANXIOUSLY AWAITING CONGRESSIONAL ACTION

A report printed in the *Red Lodge Picket* on April 12, 1890, states: "A letter received from Henry Howell, who is at Cooke City, states that there is now six feet of snow on a level in that camp, and in many places it is twelve feet deep. From present indications there will be no scarcity of water during the coming summer."[122] Despite the deep snow, the road to Cooke City had been cleared by mid-April, allowing wagons to take the place of sleds on the road to Cooke.[123] By May, the streets of Cooke City were livening up as well as changing. The *Livingston Enterprise* reported that the firm of Nichols and Chittenden was

> *erecting a handsome two-story business building..25x75 feet in size* [and that] *to stock this they have just ordered a large invoice of general merchandise of all kinds, and as soon as the building is completed and the goods received they will have one of the most complete general merchandise stores in Park county…such enterprise is highly commendable, and this move not only shows the prosperous condition of Cooke, but the abiding faith in her future greatness held by such sound business men as compose this firm.*[124]

The building they constructed still stands today, although it has undergone some modifications, and is currently home to the Cooke City Store.

This faith in prosperity enthusiastically carried over into a Potts and Webster ad that claimed "the Cooke City Railroad is now an assured fact. The bill granting right of way to a railroad will open up and make possible the development of the richest mining camp in Montana. If you want mines call on or write us."[125] The residents of Cooke City were optimistic, too, with the *Red Lodge Picket* noting a conversation had with local Pat F. Hanley, who thought that "Cooke City will make one of the greatest mining camps in the world" and who also said "it was amusing to watch a Cooke millionaire washing his clothes and cooking his vituals [*sic*] and doing other chores unknown to the millionaire of the effete east."[126] In July 1890, the *Livingston Enterprise* published a column written by "MOUNTAIN PINE" and titled "Cooke City Gleanings" that gave readers tidbits of information about the camp. One note supports this optimism in the face of discouragement: "The delay of the passage of the railroad bill, which would seem just cause to discourage the many miners who have 'borne the burden and heat of the day,' seems only to anchor their hopes more firmly

on the future greatness of Cooke, which even to the most casual observer appears certain." MOUNTAIN PINE also reported the completion of Nichols and Chittenden's store—"a credit to them and an ornament to the town"—and noted that "new arrivals come in on nearly every stage, either prospecting or to spend the summer in the bracing air of Cooke City." The writer concluded that "with this characteristic push and perseverance of its people, combined with its vast stores of wealth that no one can compute, Cooke is sure to be nearing that 'good time' for which so many here have nobly labored and still are waiting."[127] In August, the column was again published by the *Enterprise* with an unknown author; perhaps the notes had been gleaned from various letters and compiled by an editor. Regardless, the residents of Cooke remained in good spirits. The notes began: "Another week of delightful weather, and while we read of the intense heat in other localities, we (who are enjoying the cool, bracing air of Cooke) can only imagine how the poor unfortunates feel who are in the heated districts." Again, the notes concluded that "railroad news is meagre, but we Cookites have strong hopes that the 'scenery cranks' may be overruled and the sound of the car whistle yet be heard in our land."[128] The miners, investors, railroad tycoons, politicians and environmentalists would come to weave a tangled web when each was left to vie for their own personal gain, and Cooke City would fall prey to all of their triumphs and failings.

The railroad issue was in full swing in early 1890, with Representative Charles Eaton taking the lead. On February 8, the *Livingston Enterprise* published the memorial he had introduced in legislation that called for senators and representatives alike to segregate the portion of the national park necessary for the New World Mining District to acquire railroad transportation. Eaton briefly described the land over which the railroad must cross, explaining that the Yellowstone route would be the only practical route, and that little to no tourist sites would be disturbed if the northern boundary of the park were to be moved. He concluded, "therefore, in view of these facts, these memorialists pray that your honorable bodies will enact a law" that would allow the miners access to their holdings.[129] Eaton's actions created a stir amongst both supporters and the opposition. When the *Livingston Enterprise* announced that articles of incorporation had been filed for the new Montana Mineral Railroad company, with both George and Charles Eaton's names listed as incorporators, the latter brother found himself in hot water.[130] A month after this notice, the *Enterprise* wrote that it was "not aware that C.H. Eaton is interesting himself in a franchise for a railroad through the Park" and that they were "not prepared to believe that

our worthy congressman is interested in the proposed franchise."[131] The *Post* quickly took note of this inconsistency and used it to make a case against the *Enterprise*. The *Enterprise* quickly retorted: "There is nothing inconsistent in the action of Representative Eaton in joining in an incorporation for the purpose of building a railroad along the Yellowstone river, the East Fork and Soda Butte creek to Cooke and his efforts to secure the adoption by the late legislature of a memorial praying congress to segregate a portion of the park." This issue was heightened when *Forest and Stream* published an article stating that the "opposition to a Park bill in the house of representatives has come from people who desired to obtain a franchise for a railway to run through the Park."[132] Eaton seemed to be on two sides at once, pushing a bill that would segregate a portion of the park for the railroad while simultaneously lending his name and probably some financial assistance as an incorporator of a railroad company vying for a right of way through the national park. The *Enterprise* called for a railroad at any cost, appearing to take no real opinion as to how it should be done—just so long as it came from Cinnabar: "It is therefore of vital importance that this route should be secured for a railroad, and if the opponents of the proposed right of way through the Park are in earnest in their efforts to prevent it, we see no more effective way of disposing of it than by supporting the proposed bill for the segregation of that small portion requested by the true friends of Cooke City."[133] The *Enterprise* nearly always presented itself as the voice of the weary miner, the proponent of truth and justice, so such a declaration in support of a railway, however it could be accomplished, seems fitting.

The *Billings Gazette* once again pitted itself against the possible success of its rival Livingston in the railroad matter, prompting the *Enterprise* to note: "This proposition to secure a right of way to Cooke City over the only feasible route that exists has been opposed by a certain element in Billings ever since it was first suggested." The route was, of course, through the national park to meet the Cinnabar terminus. The *Enterprise* conceded that "some excuse on purely selfish grounds, while the right of way through the Crow reserve for the Billings, Clarks Fork & Cooke City railroad was pending cannot be denied," but that "since that right of way has been secured and two years' time has demonstrated the impossibility of enlisting capital in so hazardous and stupendous an undertaking as the construction of a railroad to Cooke from Billings, no such excuse exists." As such, the *Enterprise* proclaimed that "the people of that city can no longer attempt to deprive Cooke City of needed railroad transportation without placing themselves in an unenviable light before the people of the state." The article concluded: "Healthy and

spirited rivalry is commendable, but a 'dog in the manger' policy will be universally condemned."[134]

The *Enterprise* brought up a good point that hadn't been thoroughly investigated about the Billings route. While Billings investors were presumably working to upend the Livingston route, it had failed to take action on its own. A route through the Clarks Fork would no doubt be a "hazardous and stupendous" undertaking, and one could argue that the possibility of the Yellowstone route would alter an investor's opinion on the matter. If the Billings route was the only one available, surely, investors would take a closer look at the prospects. Two years of waiting had demonstrated this lack of enthusiasm so long as the Yellowstone route remained a viable option. The *Red Lodge Picket* reported that many people were of the opinion that Cooke would not get a railroad for at least two more years—"the argument they give for their theory in the matter is that certain capitalist want to corral more mining property before the camp is connected with the outside world by railroad communication."[135] Such theories must have been tossed about throughout the long winter months that the miners of Cooke City spent in these nearby towns; a reason had to be found to account for their continued bad luck in the railroad matter. Meanwhile, the *Enterprise* carried on as the defender of the miner, throwing back what the *Gazette* dished out. When the latter published information on the habits of wildlife living along the proposed rail route through the park, the *Enterprise* gladly published the opposing opinion of "AN OLD TIMER" out of Cooke:

> *I will begin by saying that the statements contained in the recent interview published in the* Billings Gazette*—to the effect that so much game winters on the line of the proposed railroad from Cinnabar to Cooke, and that he saw elk, deer and sheep, five hundred or more—are totally false. There are no deer or sheep wintering on the east park anyway, and what elk there are winter from three to five miles south of the proposed railroad line, and I can truthfully say there is no game of any kind wintering on the proposed line or the north of it, and I do not believe the party who gave it to the Gazette can tell an elk from a jack rabbit, for that matter.*[136]

The OLD TIMER concluded the letter with "What we want is to see the cars come." No such sight would ever come to be in the valley of the waiting miners.

Barnacles on the Body Politic

On April 19, 1890, the *Livingston Enterprise* reported that Montana state senator Thomas Henry Carter had backed the plan for an exclusive railroad franchise to be granted to a company through the park. The *Enterprise* implored its readers to see that this was a "matter of serious importance to the mine owners of Cooke, and this action by the house committee is to be deplored, as it indicates that the parties interested in this exclusive franchise would rather Cooke City should remain without railroad facilities than that they would be deprived of an opportunity for speculation and individual gain."[137] The *Enterprise* had also come into receipt of an incident that had occurred at the house committee on public lands meeting, stating that "quite a scene occurred in the committee when a man named Phillips appeared and denied that there was any mineral in Cooke City."[138] One of the Cooke City men stood in defense, but Phillips quieted down, and nothing further commenced. On May 10, the *Enterprise* noted that nothing new had come of the legislation revolving around the railroad, and nothing would be expected, since the recent sudden death of a senator had disrupted the session.[139]

The *Helena Independent* soon came to the aid of the *Enterprise*, attacking eastern newspapers "published 2,000 miles from the Yellowstone Park," which the *Independent* claimed "imagine that the park is a highly cultivated little tract of a few acres like a city park, instead of a domain larger than some of the New England states."[140] The *Independent* proclaimed all objectors as sentimentalists, a term that would often be used for those to whom the park must remain in its unspoiled condition. This issue of a railroad was about more than money—it was a platform to establish the definition of a national park. The two plans set before legislation—one to obtain exclusive rights through the park, the other to segregate the land needed from the park boundary—both intruded on the proposed use of the national park. U.S. senator George Vest, in strong opposition to the exclusive rights plan, stated, "if one railroad is permitted in the Park there will be three or four more in a very short time, and the Park might then as well be abandoned."[141] Meanwhile, the seemingly impartial (to either the segregation or the right of way bill) *Enterprise*, starting on March 8, had indeed changed its tune by the end of that month, mercilessly giving the franchise group an ultimatum: if that group were "actuated by unselfish motives and are only interested in the welfare of Cooke, they should abandon their scheme" to join in the efforts of the segregation plan.[142] The franchise bill was seen as an ill-fated detriment

to the segregation bill; its continued push called for the downfall of any and all legislation that would lead to a transportation plan for Cooke City from the west. While many legislators did support some sort of plan to provide relief to the Cooke City miners, many were also adamantly opposed to either plan. Congressman Francis B. Stockbridge was targeted by the *Enterprise* in his opposition, with the *Enterprise* claiming that he "opposed a road to Cooke because someone would make money out of it." The *Enterprise* went on to retort: "who ever heard of an enterprise of any kind calculated to develop the country that did not originate with a view to money making? What other incentive is there for instigating public enterprises except that of pecuniary gain?" Not stopping there, the *Enterprise* continued by condemning the work of Congressman Stockbridge: "If such barnacles on the body politic as Congressman Stockbrige [*sic*] has demonstrated himself to be are permitted to have their way, an embargo would be put upon all improvement and the country forced to remain in its present condition for the next one hundred years." The paper finally concluded: "For the relief of the Cooke City miners this railroad is demanded, and it is not to be expected that it will be secured through purely philanthropic [motives] on the part of capitalists, unless such patriots as Congressman Stockbridge can be interested in the scheme."[143]

Soon, a new face would emerge in the fight for Cooke City—Alvin P. Vinnedge. On August 20, 1890, the Vinnedge Mining Company was incorporated by three members of the Vinnedge family and one Belle Drake with capital stock of $3,000,000.[144] Two years later, Alvin Vinnedge was appointed to go to Washington as a representative in the interest of the segregation bill proposed by Montana state senator Wilber Fiske Sanders.[145] Alvin came into close contact with Sanders in Washington, sending information, when possible, about the goings-on in the legislative body. In March 1892, he prophesied that he could "see no reason why we should fail, and yet we may"[146] in the railroad segregation matter.

While those living in camp during the summer of 1890 were all "anxiously awaiting congressional action"[147] and hoping to be "shortly able to ride by rail into the heart of the New World mining district,"[148] life continued on as time necessitated.

DEATH IN A MINING CAMP

DEAD AND ALONE

As the population grew, so did incidents of bad behavior and accidental injuries. The *New North-West* of October 6, 1882, humorously relates that "there was a riot at Cooke city, near Bozeman, last Friday that the local authorities could not suppress, and a call was made on Fort Ellis for troops. Town lots and a woman caused the trouble."[149] Fort Ellis would have been located 130 miles away by today's road, and there is little to indicate that "local authorities" would have meant more than men with a self-proclaimed justice of the peace. This distance was not only troubling in instances where law was needed but also when medical aid was needed. On November 22, the *River Press* related a harrowing tale that emphasizes this problem. It seems that on November 16, Clifton, a miner, had been working at the Great Republic mine, putting "in a shot" to blow out a part of the mine. Clifton and his partner had waited an hour for the shot to go off when Clifton approached the hole and the charge exploded, filling his face and breast with "fine particles of rock and dirt," while also bruising his right arm and tearing it "just below the shoulder." It took "seven days on the road" to get the injured man to medical help. The article noted "owing to the length of time lapsing between receiving his injuries and the present, the extent to which he is hurt is unknown, but his physician expresses a belief that he is not seriously injured, and that the sight of one eye, if not both, will be saved."[150]

Similarly, in 1894, the *Anaconda Standard* reported: "What might have been a fatal accident occurred at the Fisher mine yesterday. George Fisher, while crosscutting for new leads, had neglected to timber sufficiently and while he was at work in the tunnel a large body of earth and rock fell in upon him, burying him in the debris and stunning him. When extricated it was found a badly bruised side and arm with dislocated shoulder was the extent of his injuries, but it was a miraculous escape."[151] In the next report, Fisher was "getting along nicely."[152] Fisher's life, however, was nothing if not curious. In 1916, Fisher was found dead in his cabin at Cooke. The *Saco Independent* of Saco, Montana, reported the following tragic story:

> *With $500 in money on the table before him and a contract for the sale of his mining properties for $17,000 clutched in his hand, the body of George Fisher, an old prospector of the Cooke City district, was found by neighbors, who missed him from his usual haunts.*
>
> *Fisher had shot himself in the temple. It is believed he thought he had parted with his mines at too low a figure. Fisher always believed his mines had a great future and that he would some day be enormously wealthy. He willed all his money and effects to a friend. He was unmarried and, so far as known, had no relatives.*[153]

Fisher's life was anything but straightforward. Eighteen years after his death, he was honored with a military headstone.[154] On it were printed two names: Jacob Bach and George Fisher.

From what can be gleaned from newspaper articles and government documents, on February 17, 1865, twenty-year-old German immigrant Jacob Bach enlisted in Company A of the 2nd Pennsylvania Cavalry. During the war, he spent most of his time in Virginia before being discharged only five months later at the end of the war.[155] He spent several years in the early 1900s filing for a pension, with difficulty, as there was no evidence of an honorable discharge, the paperwork having been lost in a fire. In 1889, Bach appeared in the *Livingston Enterprise* Holiday Edition featuring mining properties at Cooke; his name was printed as George Fisher, but the man was the same. The *Enterprise* had high praise for the work Fisher had completed on his mine, the Elkhorn, stating: "the mine is a monument of what one man without capital can do in the way of prospecting." Fisher was said to have six hundred feet of tunnels dug on his claim, which had brought him in contact with a six-foot vein of silver, and that in 1885, he had sent "several car loads of ore to Omaha, on which he received returns

of over one hundred dollars per ton," but after "paying fifty dollars for freight, a good portion of the profits, no more was shipped."[156] A year later, it was again noted with praise that Fisher was a "prince of prospectors" who had "singlehanded and alone…toiled through winter and summer" on his claim.[157] George Fisher is listed as his name less than a dozen times in the papers, almost always in connection with his mines, leaving his true identity unclear. Maybe Jacob Bach was a man he wished to leave behind; maybe he caught up to him in the end. In this way, the effects of the Civil War left its mark on many a man out West.

Many more accidents occurred over the course of 1894, including an incident with an ax and one with a hay rack in which an unfortunate man had the end of his finger "badly ground off."[158] On September 8, 1895, the *Anaconda Standard* printed a dispatch from Livingston, titled "Dead and Alone," detailing the death of an old teamster named Becker. The man had worked for the Blandon Mining and Milling Company at Daisy mine and was employed to haul ore from the mine to Cinnabar. The article noted that Becker was found

> *a few feet behind his wagon, dead, with his chest caved in. The dead man still had a hold of the lines. The horses were standing still, having been turned up against the side of the bluff. No one witnessed the accident, but it is supposed that the heavily loaded wagon got the start of the teamster, and that to save a general wreck he steered up against the bluff, when the wagon struck a rock, throwing the driver off and under the wheels.*[159]

As was often the case, the body was sent home to relatives for them to bury.

While the preceding accidents were the result of hard work, the following, which occurred in 1892, had more to do with too much enjoyment. A freighter named Pritchard was transporting a load of goods to Cooke from the Soda Butte Station. "Among the freight was a quantity of liquors and to these Pritchard devoted so much attention that he became intoxicated, and while in this condition he was thrown from his horse and his right leg broken." He lay there overnight before he was discovered and cared for. "The delay in receiving medical attention resulted in a swollen condition of the limb and at last accounts it was supposed that amputation would be necessary to save the life of the injured man." Simple accidents could lead to dangerous consequences without proper care—something that no doubt haunted those who worked alone in the mountains like George Fisher.

His Teeth Were Good

One extraordinary tale of survival appeared in the *Big Timber Pioneer* on February 11, 1897, with the intriguing title: "Gnawed His Way to Liberty." If that wasn't enough, the first line of the story read: "It isn't often that a man owes his life to a good set of teeth, and yet to Tom Robbins of Cooke City, belongs that distinction." In a letter to his family, the manager of the Daisy mine, Henry Jurgens, told this story of Robbins, a prospector and "hardy mountaineer." Robbins had headed to his mine, located six miles from Cooke City, with the snow being unusually deep. Not deterred by the snow depth, Robbins strapped on long Norwegian snowshoes and headed for the mine, stopping to dine with ex-sheriff Jurgens along the way, who "made a hospit[able] host whether in the mountains or in the city." About a mile from the Daisy mine, Robbins was "caught in a snowslide" and "carried down a considerable distance." The letter noted that he was "alone and covered with snow for several feet" and that he had "a heavy pack on his back which, because of the weight of the snow upon him, interfered with his movements and, try as he would, he was unable to make any progress." It seems Robbins's arms were pinned, and things looked bleak, when "at last a brilliant idea came to him." He decided to try and gnaw his way through the rope that held his pack, and as "his teeth were good," in time he "broke the rope and freed himself from the pack."[160] Following removal of the snowshoes, and after "much effort," he made his way out of the slide—a narrow escape indeed.

The article went on to note that many such accidents occurred in the mountains of Cooke City every year, with sometimes less fortunate results. Jurgens explained that "the men as they plough through the snow on the side of a mountain cut a line that often causes a slide of hundreds of feet. The line gives a chance for the snow to break, and when it does it may carry the unfortunate man who is responsible for it down with it."[161] Because of the drama associated with such stories, they were often retold tales that found an attentive audience in the late 1920s. Martin Ranmael, a Norwegian miner turned rancher, had spent considerable time in Cooke City during the late 1880s. In 1928, the *Livingston Enterprise* ran an article that detailed some of Ranmael's dramatic experiences at the camp when he used to haul mail into Cooke. In one such story, Ranmael was on a mail trip when an avalanche started above him. It was noted that he "had an 11-month-old pup with him that he had taught to ride on his pack when he was making such fast time on his skies that the pup could not keep up." He had "instinctively" jumped to

Tredennick children in downtown Cooke City looking east. *Kathy Kleppinger, Tredennick family*.

the side of the mountain and "pushed on the skis to make greater speed" in order to escape the path of the avalanche. During this escape, Ranmael "felt something tighten around his neck and discovered it was the dog, which was trying to hold on by its paws."

When he finally stopped, he found that the slide above him had "only settled slightly but the slide below had accumulated force until it had gone over a cliff and dislodged a great mass of snow, enough to make 36 carloads." Such experiences, if survived, made wonderful instances to brag about one's skill. Ranmael, of course, did have more than a few of these experiences to add to a conversation. In one of his proudest moments, Ranmael set out for a ski with no evident objective in mind besides having a bit of fun. He later described the snow as "excellent for skiing" with a crust on top and that the "slope was so steep that he lost his breath and more or less automatically slowed down" on his descent down the mountain. With his eyes blinded by the snow, he did not see a "deep sag" and thus "found himself sailing into space." It was said that "the men who were with him estimated that he went nearly 100 feet in the air which was near enough a record to satisfy him." Ranmael would state that he doubted if "Lindbergh ever went through the air faster than he did coming down Sheep mountain." Ranmael recalled many of his other close calls to the *Big Timber Pioneer*, including "a fall over a 60-foot cliff with only a sprained wrist as a consequence and a slide down an icy slope of Pilot and Index which was stopped by an opportune rock with

no other loss than the seat of his trousers."[162] While his stories maintained a humorous ring, there is no doubt that a less experienced skier would have faced a grimly different outcome. One only had to recall the death of the two men in the New Year's Day avalanche of 1887 to imagine the force of that amount of snow against a human body.

SUNDAY SINNINGS

Incidents were a part of the miner's life in Cooke City, however, they were not the only dangers to be found out west. Newspaper accounts that mention Cooke City in 1885 were dominated by a murder that occurred in Bozeman, with the victim and his killer having been business partners in a saloon in Cooke City. The exact name and location of the saloon is unknown, although there were probably a half-dozen in existence at the time. The incident began in scandal when the *Livingston Enterprise* speculated about an advertisement placed in the paper on January 24, 1885. The advertisement had been placed by C.C. Lane and cautioned the public "against giving credit to his wife Hattie E. Lane." The paper noted that there "is generally an interesting inside history to such an advertisement" and that this one was the "story of woman's infidelity and man's rascality." It seems that in September 1884, Hattie Lane had taken a train east to Manchester, Iowa, to visit with her family. She wrote "frequent letters" in the most "affectionate terms" to her husband over the next three months before reportedly joining Fred P. Johnson in Sioux City and leaving with him "for some unknown destination." Neil Lane and Fred Johnson were business partners in Cooke who ran a saloon together. Prior to their departure from Cooke, the paper notes that "both he [Johnson] and Mrs. Lane seem to have played a deep game." Johnson had been secretly disposing of their partnership property, pocketing the proceeds while also borrowing "small sums of money from any and all who would loan to him until the aggregate obtained in that way must have been a large amount," all while receiving funds from Neil Lane for his expenses. Meanwhile, Hattie Lane, after a brief altercation with her husband regarding her fidelity to him, had gotten back into Neil's good graces to the point where "property in the form of deeds and mortgages" were placed in her name. While in Iowa during the latter part of 1884, she disposed of real estate there, with her husband assuming that they would use the money to take a trip to the Pacific coast together. By mid-January,

Hattie had eloped with Johnson instead. According to the *Enterprise*, Neil had "taken legal steps to recover his property held by her in trust," but it was noted that beyond that, he would "probably take no measures against his erring wife and her sneaking paramour unless they cross his path."[163] By February, the *River Press* affirmatively wrote that Fred Johnson had left the area with bills unpaid ($500) and his partner's wife in tow.[164]

By April 1885, matters had come to a head when Johnson returned, and Lane sought out ill-fated revenge. Initial reporting occurred on April 28 in the *Daily Yellowstone Journal* under the headline "Sunday Sinnings." It was noted that the two men had a quarrel over a woman, and that the incident had occurred at a saloon in Bozeman, which was described as "100 feet deep by 25 feet wide" and "the finest place of the kind in the territory."[165] One can't help but note the pride at which the newspaper described the location of the murder. The following day, the paper had the inside scoop and enthusiastically related the story with the headline: "Details of the Killing of Neil Lane—Jealousy the Root of the Trouble." The article gave readers a slight history of the issues that plagued the threesome and explained that the former Mrs. Lane and Johnson had made and carried out plans to "euchre" her husband out of his business and property before running off together. The paper then proceeded with the details of the recent murder, when all had come to a head:

the men had been drinking and quarreling in the saloon during the afternoon, Lane taunting Johnson and daring him to a gun fight. Johnson afterward came out of the saloon and when he was about the middle of the crossing Lane overtook him and after some talk took hold of him and forcibly pulled him some distance. Johnson did not seem to resist much more but let Lane lead him into the saloon. When Lane led Johnson into the saloon he held him by the coat lapel with his right hand; he changed his hold to the left, and thrust his hand into the pocket where he kept his gun; but he never drew it. Johnson drew his gun and, thrusting it almost against [Lane's] face, fired. The revolver was a 45-calibre Colt. The bullet entered under Lane's eye, went out the back of his skull, passed through the drum of the stove and imbedded itself in the hard wood wainscoting of the room. After firing the first shot he jumped back and, as Lane was falling, fired another bullet which passed through the flesh of his hip; he fired a third shot at Lane as he lay dead upon the floor but it missed its mark. Johnson walked out and was shortly afterwards arrested. The feeling against Lane was very bitter, and if he had killed Johnson after tantalizing him as he did, it is believed

that he never would have reached jail alive. Both men had been drinking during the day, but Johnson while calling for whiskey was not drinking it, and Lane was taking heavy drinks.[166]

This *Gunsmoke*-style drama occurred several times over the years, and in most cases, the killer was acquitted of the crime on grounds of self-defense, as Johnson was. The sentiments of the paper against Lane were, in the end, the same as those of the court system regardless of Johnson's part in the scheming against Lane. The *New North-West* reported that "the general drift of the testimony was to the effect that Lane provoked the assault; that he had repeatedly threatened the life of Johnson at Co[o]ke City, Gardiner, Livingston, and Bozeman" and that "everything tended to show that Lane had deliberately determined and planned to kill Johnson." The paper noted that "on the day of the homicide" it had "become a question to be promptly decided by Johnson whether to kill or be killed." The courtroom that day was "pretty well filled with witnesses and spectators, which showed that more than ordinary interest was being taken in the proceedings and result." This may have been due to either the public location of the incident in question or the amount of publicity Lane had received in the prior year over what was ultimately a private affair. Those in attendance promptly witnessed the verdict of the case, which ruled the defendant be discharged and acquitted of the crime, which was expected to be met by "universal approval."[167] It is unknown what became of the saloon once owned by the two men.

In 1892, a considerable amount of attention was paid to the killing of William Chick at Cooke City. On September 24, the *Livingston Enterprise* first broke the news of a "shooting affray" in which Bill Chick, "an old timer of the camp," had been shot by a stranger on September 21.

The paper reported that "it is supposed the shooting was the result of a drunken quarrel, and that Chick's wound is dangerous, if not fatal."[168] The *Anaconda Standard* reported two days later that Chick had died from the wound three hours after the shooting, and that the stranger had been placed into the local jail. It was also noted that Chick was a man of about fifty years of age, unmarried and "quarrelsome when drunk, but a kind-hearted and genial man when sober."[169] A man named E.R. Bowen related that Chick had quarreled with a soldier in Cooke who had "interfered with Chick's horse" and when told to stop had replied that "he did not know whether he would or not and didn't know whether Chick could compel him to."[170] It was supposed that this altercation had been resumed on September 21 and resulted in Chick's death. The details of the murder did not publicly surface

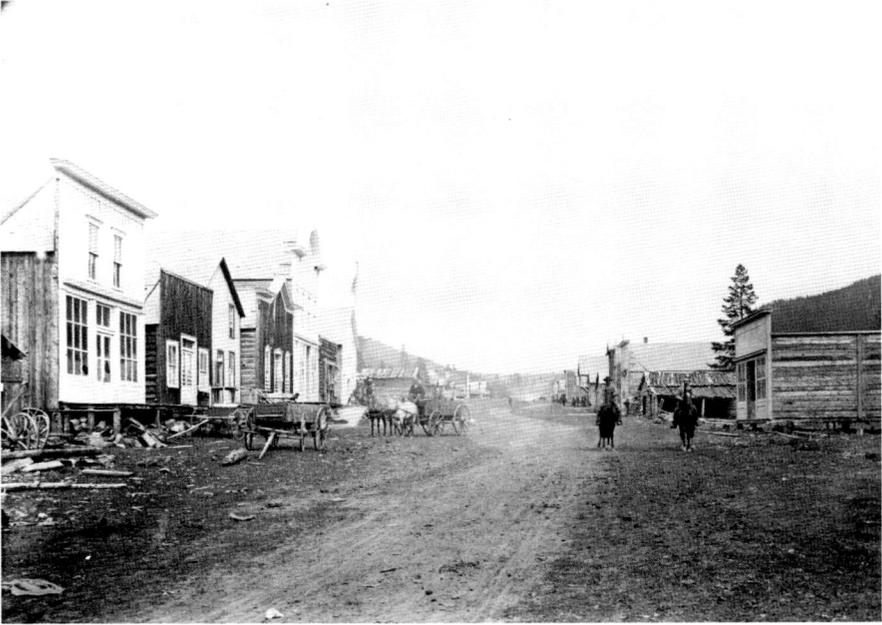

Cooke City looking east; Cosmopolitan Hotel on the left. *Yellowstone Gateway Museum of Park County, 2006.045.0525.*

until January 11, 1893, when the stranger, James Malloy, was put on trial, with the case deemed the "most important criminal case to come up" during the term.[171] These details were disclosed in a special dispatch to the *Standard* and seemed to indicate a lack of prowess on the part of the prosecution, who had "not called witnesses whose names were endorsed on the information" and that the "allegations in the information had not been proved" by the four witnesses who had been put on the stand. A man by the name of B. Morgan gave the following testimony, as noted by the *Standard*:

> *Chick and Malloy were standing in front of the store and Chick drew a large butcher knife and said to Malloy: "You --- ---, I'll cut your liver out and feed it to the buzzards." Malloy said: "I want you to leave me alone, as I don't want any trouble." Chick then shifted the knife to his left hand, reached under the left side of his coat with his right, and drew a revolver and started towards Malloy, again repeating his threat. Malloy grabbed a rifle that stood against an empty oil can, jumped off the porch and started to retreat backwards. Chick said: "You coward, you're afraid to fight," and jumped off the porch, took a step or two forwards and fired at Malloy, who*

then retreated about 30 feet. As soon as Chick fired, Malloy drew the rifle to a level with his hip and fired. Chick fell with the gun in his hand. Malloy then said: "Someone take his gun and I will give up." Morgan went to take Chick's gun and Chick pulled the trigger, but the bullet went into the air.[172]

Morgan's testimony was corroborated by other eyewitnesses, one of whom was miner Bert Holland. The defense pleaded for acquittal, and the jury brought back a verdict of not guilty. Malloy was a free man and was not heard from again. So did Cooke City play into the theme of the "Wild West."

NEWSPAPER CORRESPONDENCE

THE LIVELIEST IN MONTANA

With business booming, the town of Cooke City saw some growth. The mineral wealth was proven and the men were at the ready—transportation was the only thing lacking. On July 31, 1889, the *Great Falls Tribune* singularly stated, "Cooke City wants a hotel."[173] Unless visitors were dissatisfied with the 150-room Cosmopolitan Hotel, it would appear visitation was at a peak for the town to be in want of another one. Meanwhile, the Cosmopolitan's proprietor, Jack Allen, seemed to have run into some bad luck. In August, he sent the following notice to the *Livingston Enterprise*: "NOTICE TO ALL MEN. – Notice is hereby given that Francis B. Allen, my wife, having left my bed and board without any just cause, I will not be responsible for any bills contracted by her from this date. –JOHN P. ALLEN."[174] Soon after, the couple divorced. Allen spent the winter of 1889–90 making a "two month's visit to his old home in Rhode Island."[175]

Along with a hotel, the three hundred voters in Cooke believed they were "entitled to better mail service" and sent a petition stating as much to Washington.[176] The petition asked for a daily mail service—a sure sign of the business that was being transacted at the mines. White, Johnstone and Company, a real estate firm out of Helena, ran an ad in the *Helena Independent* on August 8, 1889, claiming that "a corps of engineers are now in the field surveying a line for a railroad extension to Cooke City. The building of this

railroad, which will probably be within a year, will make this camp, with its inexhaustible deposits of ore, one of the liveliest in Montana." The company had advertised "50 desirable business lots in Cooke City," with prices ranging from $50 to $150 each. Such property was "sure to have a rapid increase in value."[177] That summer, Major George O. Eaton had "bonded the Republic Mining Company's smelting plant, mines, supplies and real estate" to a J.A. Clark for $230,000. The *Livingston Enterprise* reported that "there is no property in Montana that offers so rich returns for the investment as the Republic mines and plant and that "Mr. Clark has, in securing this property, not only acquired a bonanza but through his efforts will enlist capitalists in the development of the camp, and thereby secure to the New World district the necessary transportation to make it the greatest producing district in Montana."[178] By September, Charles Tappan had prepared a "handsome blue print map of Cooke City, showing every mine and mineral location so far made in that camp" for those interested in investing in them.[179] No doubt many of those maps were sold to men looking for opportunity and hoping to make their mark on industry.

One such man was Nick Tredennick. Since his arrival in the early 1880s, Tredennick had risen from his position as foreman of a group of mines

The Tredennick home. *Kathy Kleppinger, Tredennick family.*

bonded by the Republic Mining Company to become a company owner himself. He had been the foreman at Republic in 1887, when an avalanche claimed the lives of two miners, and had left and become foreman at Nye City later that same year only to return to Cooke soon after.[180] Nick was in business with a relative, Stephen Tredennick, and J.B. Humphreys in the summer of 1889, when a fire burned a Tredennick, Humphreys and Company cabin with damages totaling about $1,000.[181] These hardships would do little to deter Tredennick from returning time and again to the mines of Cooke City, and he devoted over fifty years of his life to those mountains.

Nick Tredennick no doubt took part in many an election, as Cooke City was positioned in a highly political area. On September 21, 1889, a Republican rally was held at Cooke for the first time. It was reported in the *Livingston Enterprise* that the "citizens assembled at the office of District Recorder Vinnidge [*sic*] to the number of over one hundred, a portion of the audience being composed of ladies." Three Republican candidates for the legislature addressed the audience, with one of them being Charles Eaton. It was said that Eaton "in well-chosen and forcible language, briefly discussed the issues involved in the campaign" and that "his remarks were listened to attentively and elicited frequent bursts of applause."[182] In the years to come, Vinnedge, the district recorder, would also play a large part in the fight for Cooke City railroad transportation, spending most of his time in Washington, D.C.

Will Send You an Account of It in My Next, If I Live

For those living in the camp, life continued with the seasons, and as winter came, many miners left the valley, as described by "PYRITES" in a letter from Cooke City dated November 7, 1889, and printed in the *Livingston Enterprise*. PYRITES wrote: "The cold, cheerless weather which has prevailed in this altitude for the past two weeks or more has been the occasion for many people leaving camp, which has had the effect of reducing our ranks to a considerable extent."[183] Many of those who left, however, were only ever present seasonally, although they did claim a residence at Cooke City. Even with such a seasonal drop in local population, PYRITES gave an estimate of "150 souls, most of whom will likely winter in camp" as the present

population. This amount is not too far off the winter populations of today. Those "150 souls" prompted freighter A.T. French to report to the *Livingston Enterprise* "his intention of keeping the road open into Cooke all winter, in fulfillment of his mail contract" for the winter of 1889–90.[184]

During the next few years, local newspapers started to publish small columns of news collected from letters written by those living in Cooke City; this must have had some correlation with a consistent mail route. One such letter contained a report on snow depth, an election and an update on illness that had swept the camp and was written on February 5, 1890, by the anonymous "TRUTH" and addressed to the editor of the *Livingston Enterprise*: "I will begin by saying that the lagrippe has disappeared from amongst us.... While it lasted the boys went for hot whiskey, and Joe [Wells] is libera[l] and never charges for medicine. They had a good thing. Joe told them his wood pile was getting low heating water, but the boys pleaded zealously at the bar for more, and I verily believe they coughed and strangled a long time after the disease had left them." TRUTH went on to state: "Luckily there were no deaths. If there had been there were not sober men enough to bury the dead. Think of going a mile and a half on snow shoes and hauling a stiff on a hand sleigh, and snow four feet deep, when we had a good warm fire to sit by and hot whiskey brought us."[185] The local cemetery was indeed a little ways out of town, and it is unclear if such a burial could have been made in frozen ground once the four feet of snow had been cleared.

It was during this time that a $35,000 bond came up for the vote that would make Livingston the judicial head of Park County, taking the burden from the city of Bozeman in Gallatin County. Unfortunately, Cooke City was unable to take part in the vote. As noted by TRUTH, "We had no election, as neither the poll books nor ballots got here, and the judges could not find any law to open the polls and write tickets." He sarcastically added: "Some of the boys went so far as to say that it was a put up job on the part of the Livingston people to delay the ballot box and tickets, thinking that Cooke would vote against the scheme, but I think differently. The people of Livingston are as honest and conscientious as any people, if the wind does blow there."[186] The ballot box and poll books had been sent two weeks prior to the election but had failed to make their way to Cooke, although they were taken to Yancey's station, a mail route stop about a quarter of the way into the park. It was said that the outfit was "too cumbersome to carry by snowshoeing," so there they had remained.[187]

The kind of sarcastic humor displayed in TRUTH's letter was again demonstrated in a letter dated February 19 by "MOGUL" (quite possibly

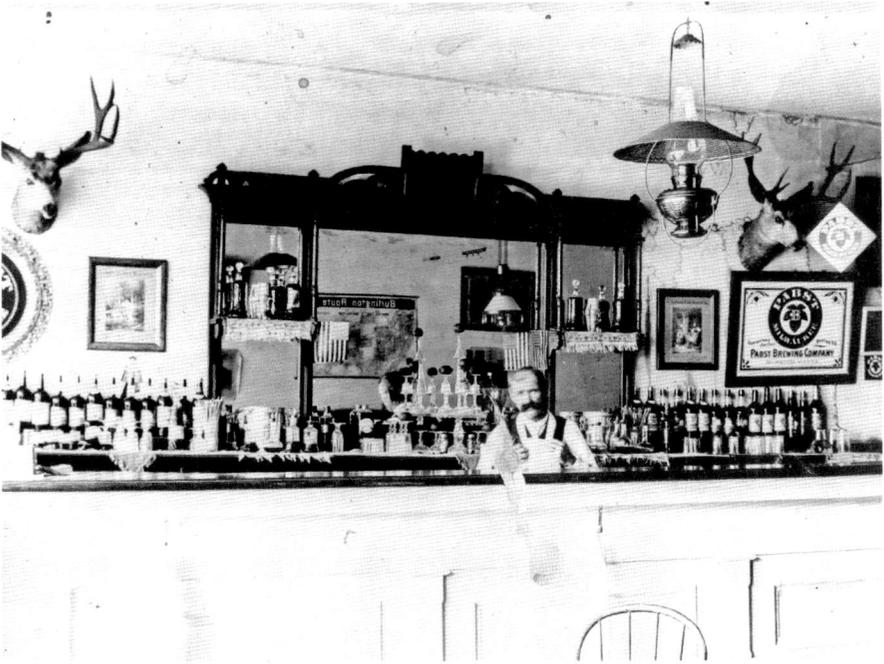

Interior of the Cosmopolitan Hotel bar. *Cooke City Montana Museum*.

the same hand) and again addressed to the editor of the *Enterprise*. "I wish to inform you that the boys have started a secret society here called the Damphool Infimary, its object being to disseminate the principles of loafing and taking matters easy generally." The "qualifications for membership" ran thus: "to drink every time any one is setting up drinks for the house." A "refusal to do so" was "sufficient cause for expulsion." Also, an applicant had to have "committed some very apparent act or acts of folly, such as holding on to a wild cat mining claim when a good price was offered them or staying in Cooke eight or nine years waiting for the boom." According to MOGUL, several men had already been rejected—one on the grounds that he was "too big a damphool," and "being rejected on that ground has a tendency to make a man cranky and hate everybody." Apparently, it was concluded that this was what ailed Cosmopolitan proprietor Jack Allen. The letter went on to discuss recent biographies, complete with photographs, that had appeared in the *Livingston Enterprise*. MOGUL noted, "The pictures you have been publishing are creating a stir in these parts. The boys have been looking up their old photos to send you." It would appear "the boys"

had spent considerable time comparing their own looks to those of the men in the photographs with an interest in who looked better and who had more hair on their heads. After a brief notice of a "ball" being held in Cooke, MOGUL concluded his letter thus: "Will send you an account of it in my next, if I live."[188]

Joyful Strains

In Cooke City, the snow was reported to be six feet deep on the level in the mountains in February 1892.[189] Regardless, the business of mining had continued through the winter months but not without a few societal breaks. On St. Patrick's Day in 1892, W.J. Vinnedge threw a "bean bay party" at the Cosmopolitan Hotel that included games, a luncheon and a popularity contest. Jack Allen was nominated for "most popular" but lost; he claimed that "popularity don't amount to much, anyway, and besides is a very poor paying office."[190] Also present were Mr. and Mrs. Curl, the former of whom would make his first visit to Livingston in two years that May.[191] Many of the local papers would print the comings and goings of residents in nearby towns, in particular the papers of Livingston and Red Lodge, where many of the Cooke miners spent considerable time in the off season. On May 28, the *Red Lodge Picket* described one such visit by Edward E. VanDyke. The hunter and trapper reported the trails via the Clarks Fork "passable all the way to" Cooke City, "with the exception of about five miles, which he traveled on snow shoes." It was described with interest that "Mr. VanDyke wore a crop of hair which reached to his shoulders, and with his trapper's dress and big gun, would present a startling aspect in the effete east." Also noted was his cargo, "the pelts of two mountain lion, nine lynx, and four black and two cinnamon bear," all of which were shipped "direct to Chicago." VanDyke also carried an ore sample, which was said to carry "87 ounces of silver and 116 of gold," and that he had "located a claim of No. 1 asbestos" three miles from that prospect.[192] If there wasn't enough excitement already, reports like this kept outsiders speculating about Cooke City.

In the fall of 1892, there had been "four saloons, two stores, one hotel and two restaurants in camp and all doing a good business."[193] The recent mining operations at the cyanide mill had made obvious contributions to the town so that by the following spring, there was serious talk of starting a second hotel in Cooke City. A letter from the camp dated April 6, 1893, said, "Easter dawned bright and with a warm wind which promises to dispel the

snow very rapidly."[194] There was more than the weather that held promise for this lively camp. There were reports of a social dance that "went off pleasantly";[195] a "glorious Fourth" celebration complete with a picnic, songs and "recitations by the school children";[196] and numerous new residences under construction as well as plans for a meat market. The *Red Lodge Picket* noted that the first load of freight into Cooke City that spring had consisted of "beer and whiskey" and that "grub was a secondary consideration."[197] The *Anaconda Standard* noted that Jack Allen had purchased "a new flag and now has the ensign of liberty floating out to the breeze above the Cosmopolitan."[198] All of this indicated a booming town seemingly on the edge of major development. The success of the mill had indeed affected the community; as noted by the *Standard*, families were "preparing to move down to Cooke again from the Alice E., where they have been living the past eight months" to "allow the children to attend school, which opens May 1."[199] There were even plans to continue the Montana Southern telephone line out to Cooke City, which "second only to the construction of a railroad" would prove "a boon" to the camp.[200] This endeavor was no doubt brought on by the successful development of the mines and a need for better communication through which people could conduct business. The camp would not receive telephone communication until much later, however.

Consistent communication was a constant problem for the residents and businessmen of Cooke City. In mid-May 1893, A.T. French's stage line sustained a loss by fire that took a stage, pair of horses and the supply of hay and grain, which delayed Cooke City mail by two days.[201] In October, the Northern Pacific stopped delivering mail from any points beyond Livingston, leaving Cooke City—along with other points in between—without any means of communication.[202] By November, the residents had held a meeting to consider a mail route between Cooke City and Red Lodge.[203] The following winter and spring, mail was brought in once every three weeks on horseback from points unknown.[204] Issues with the mail continued to plague the community throughout the coming years, with delays arising from the postal system, train lines, stage lines and weather conditions. For many years, the mail was brought in from Columbus through Absaroka and Nye before reaching Cooke City.

In 1894, French again sustained a loss of a valuable stage horse while trying to ford a river; flood waters had been high that year and had washed out the bridge.[205] This was a common occurrence, unfortunately, that caused much dissatisfaction amongst the residents, particularly the ones who stayed throughout the winter months.

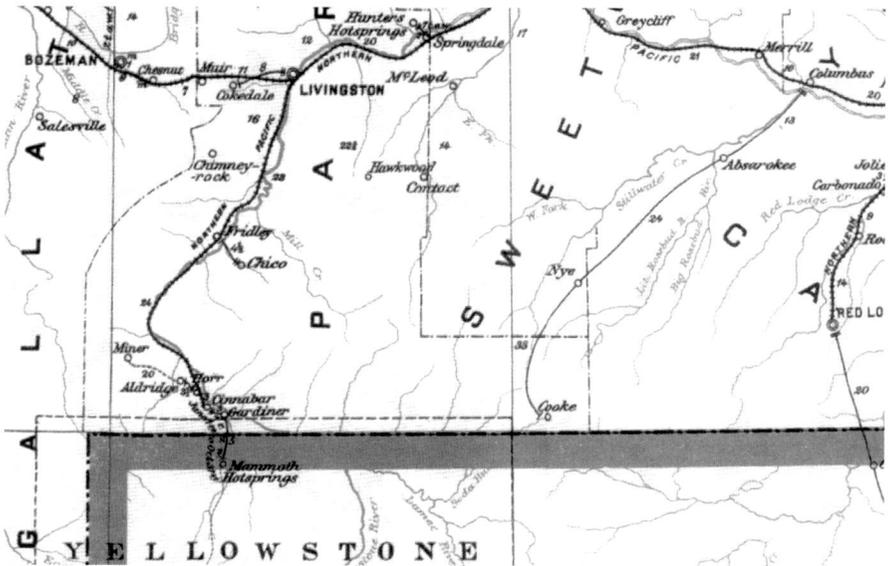

Postal route map of Montana, dated 1898, with the route from Columbus through Absarokee and Nye marked through to Cooke. *Gallatin Historical Society/Gallatin History Museum.*

In other news, a fire in February 1894 took the residence of R.B. Emison, leaving only the outside of the house standing. And disappointment came to town when the "great Corbett-Mitchell prize fight" failed to visit Cooke City despite a push made in the town in a "willingness to be great."[206] A gathering of violinists at a home in Cooke City in March made "joyful strains" that echoed "from the mountains sides through the evening hours."[207] The spring came on hard in the region, with a great loss of cattle in the surrounding ranch country due to a heavy late spring snow.[208] In April, the camp's water supply was running low, but it was noted that the problem would not last long given the amount of snow still on the ground that would soon melt.[209] By June, the majority of the residents, businessmen and miners who had been absent for the winter had returned, and the physical business of mining commenced. All provisions had to be brought in for the summer months, and with an increase in population that included many a family, local stores bulked up on goods for both residents and visitors. In mid-June, William Hague arrived with a party of "eastern tourists" to spend the summer "in the mountains for pleasure and fishing."[210] Such trips would foretell the industry that would become Cooke's mainstay: tourism.

THE RAILROAD SAGA CONTINUES

WHAT IS TO BE THE END?

On December 16, 1891, a notice appeared in the *Livingston Enterprise* informing the public of a meeting held in Cooke City during which it was unanimously decided to back the Montana Mineral Railway Transportation Company's plans for an exclusive right of way through the park. By January 2, 1892, the paper had printed a petition from Cooke City's residents denouncing the previous notice as "a fabrication without a shadow of semblance of truth," and stating that the undersigned residents "deny any such meeting was ever held in Cooke City." The petition went on to state that the segregation plan was favored amongst the majority of the residents, but of course, if that plan failed, they would hold no opposition to the right of way plan. It was concluded that "this statement is made solely to disabuse the minds of the public and to correct any impression which may have been made by said pamphlet to the effect that the people of Cooke City are in any way assisting to fly the kite of the Montana Mineral Railway and Transportation Company." The signatures read as a "who's who" of Cooke City and included J.P. Allen, the Vinnedges, George Fisher, Horace Double (who would later own the homestead patent to land destined to be Silver Gate), E.C. Kersey (who grew hay for the pack animals), Arlington Gill (who was killed in a mining accident less than five years later), William Chick (who was murdered before the year's end) and H.B. Potter, also known as Judge Potter, one of the colorful characters of Cooke City.[211]

Shortly following the January 2 petition, it was announced that the "plucky mine owners" of Cooke had raised sufficient funds to send locally prominent resident Alvin P. Vinnedge to Washington in support of Senator Wilber Fiske Sanders's segregation bill. The *Enterprise* encouraged mine owners across the state to forward "monster petitions" from all mining centers and cities to show their support in the interest of those "who have devoted years of toil and expended large sums of money in the belief that the government would not deprive them of the just reward to which they are entitled"—that "with united action at this time the desired result can be obtained."[212] Vinnedge had also recently been appointed secretary of a committee formed to oversee the New World Mining District's campaign for the World's Columbian Exposition to be held in Chicago in 1893. Vinnedge was put in charge of the mineral collection, which was reported to be of "great variety and quality...equaled by few and excelled by no community in the whole country."[213] By February 13, he had arrived in Washington, D.C.[214]

Four months later, on June 6, it was noted that "news from the segregation bill is still shadowy and uncertain, keeping us all with anxious minds and hearts."[215] A special dispatch to the *Anaconda Standard* from Cooke City dramatically stated:

> *surely in the years to come when the history of Montana is written, there will be no people so much to be pitied or lionized as hero's in all its thrilling early days as those of Cooke City who have toiled and waited and still toil and wait for relief from a government that seems utterly deaf to their appeals. The battles with redskins will pale before the long-waged battles that Cooke people here waged against an unscrupulous lobby whose personal gains are all they work for. What is to be the end? Who can tell?*[216]

By the end of the month, it was said that all were "glad to hear" of the recent favorable report on the segregation bill by the house committee on public lands, this being "one step more towards success than has been attained before."[217] This favorable report had followed the passage of the segregation bill, now known as the Warren Bill, in the Senate. As noted by the *Enterprise*, "the only danger that now threatens even remotely to interfere with the passage of this measure is that congress may adjourn before a vote can be secured in the house."[218] This danger was to be rightly feared; the bill failed to come up during that session, although Chairman Thomas McRea, of the public lands committee, had received assurances that the bill would

Locals dressed in their finest for a fish fry. Nick Tredennick is first from the left. *Cooke City Montana Museum.*

be considered early in the next.[219] Alvin Vinnedge had returned to Montana from Washington by late August and was still confident about the segregation bill, stating "I have every reason to believe that the vicious opposition to the segregation bill will soon be removed. We have not been idle and I can safely say that the opposition to our bill will be speedily withdrawn."[220]

Alvin P. Vinnedge had made a name for himself with his efforts in Washington. In August, he was mentioned as a candidate for clerk and recorder of Park County. The *Enterprise* proudly proclaimed: "if there is any man in Park county to whom the people are under obligations at present it is Mr. Vinnedge…his untiring exertions assisted in securing the passage [of the] bill in the senate and a favorable report from the public lands committee in the house…the people of this county would have to reach a long while to find a man more worthy and competent than Mr. Vinnedge to fill the office of clerk and recorder."[221] In October, the paper printed an endorsement from Senator Sanders in favor of Vinnedge for the position, with the *Enterprise* stating: "Every voter should place an X opposite the name of Alvin P. Vinnedge when he makes up his ballot."[222] Vinnedge did not receive the position, however, and spent the next winter in Washington working on the segregation bill.

POLITICS, POLICY AND PANDEMONIUM

Eighteen hundred and ninety-three will be a great railroad year for Montana. With the park segregation bill passed, as demanded by the democratic state platform, the great Cook[e] City district will speedily hear the revivifying whistle of the locomotive…our prospects are bright, indeed, and there is not a cloud on Montana's clear skies.[223]

This was the optimism put forth by the *Helena Independent* as Cooke City mining endeavors prospered and the segregation bill moved forward. In December 1893, it was announced that Livingston had sent a committee of three to Washington to promote the bill, which was "the wish of every mining man in Montana."[224] Those opposing the bill were often tagged as "park sentimentalists" who, as the *Helena Independent* put it, "read about the park but never visit it and therefore are unfamiliar with the topographical features of the Cook[e] City railroad project."[225] It was this topography that shaped how the bill backing the railroad had been presented to Congress. While the house committee on public lands had reported favorably (five to three) on the Warren segregation bill in June 1892, it had only been due to a change in the location of the proposed road. Former plans had included the crossing of the Yellowstone River into park land even after segregation because of topographical issues on the north side. Senators Wilber Fiske Sanders and George Vest had both agreed that the best way to push the bill through committee was to eliminate that clause, keeping the road on the segregated portion of the river only. The strategy had worked, but it did not change the strong opposition still present in both houses of Congress. Early in 1892, a right of way bill had been introduced—a bill that Vinnedge had a strong opposition to, stating in a letter to Cooke City: "I think I can see how, with the numerous and malignant forms of human greed that breed and spread like a contagion pestilential, and that, barnacle-like attach themselves to all legitimate ventures of human industry, complications may yet arise that will yet greatly retard and possibly defeat our cause in the house." He added, "it is not 'Rum, Romanism and Rebellion' that is the matter with this congress, but politics, policy and pandemonium. Will write you again soon."[226]

Vinnedge was correct with his qualms about the possibility of complications leading to defeat. By March, Red Lodge had taken a stand against the Yellowstone route in favor of one coming from the east. The *Picket* proclaimed: "Segregation be d—d! Red Lodge will have her road into

Cooke before the next snow flies. Now let's all drop politics and boom that road to Cooke. This will give Livingston a worse black eye than Sweetgrass county. We will take Cooke away from her yet."[227] With this fighting spirit in mind, Red Lodge made plans to build a wagon road to Cooke City so as to become a natural "shipping and outfitting point" for the miners of Cooke City. In truth, the town of Red Lodge needed a boost in business, and this seemed to be the best way into the market. According to the *Red Lodge Picket*, with the money for construction "practically assured," engineers had been sent to check out the proposed route. They had found that "besides the freighting, a great many tourists to the Yellowstone Park will come this way as they will save over a hundred miles of travel and at once find mountain scenery equal to any in America."[228] The ambitious construction of the Beartooth Highway in the 1930s would eventually attest to this statement.

Local support of alternative plans and the franchise bill were not the only problems surrounding the segregation bill. The nationally popular magazine *Forest and Stream* had issued a pamphlet with statements in opposition to the latter bill by Roosevelt and Phillips, two influential men who had stood before the public lands committee only a year before in support of the bill. A letter from Cooke City called both men "worse than snakes" in altering their position on the matter, stating "its not their outside coat they yearly shed but their whole thoughts and 'positive convictions.' God pity them."[229] While many still believed in the segregation bill, by the summer of 1893, local papers had begun to show doubt. The *Big Timber Pioneer* proclaimed "TRUE friendship to the mines of Cooke City by those who encourage the finders and builders of new roads into that great camp. The one route idea is about played out."[230]

By May 1894, one of those alternate routes was, unfortunately, not looking good. The Rocky Fork and Cooke City Railroad was in hot water when an investigation of the Northern Pacific found the stock had been "well watered," meaning that $2,000,000 of stock had been issued when the capital stock of the railroad had only been $740,000.[231] Millions of dollars were reported missing or unrecorded in the Northern Pacific books, which would be detrimental to their involvement in any further dealings with the railroad to Cooke City.

Over a year later, in November 1895, things were again looking up for the camp, with the *Anaconda Standard* printing: "Cooke City Happy, A Boom Stares the Place in the Face Just Now" upon receipt of information that the Daisy mine had sold to Aaron Bliss and capitalists. It was noted that the sale "awakened increased interest in the many promising properties of the

isolated camp and inspired the owners of the numerous rich claims with new hope and new courage." Old-timer C.W. Anderson was optimistic about the outlook—even going as far as to say that it would not surprise him to see "a thousand men in the camp"—but did prophesize correctly about the disappointing outcome of the segregation bill, stating: "to tell the truth, I don't think congress will ever pass it…chances are that the bill will remain dead a long time."[232] This was a sullen reminder of the latter half of a one-note line published earlier in the year by the *Standard*: "Cooke City is out for a railroad and she'll have one or bust."[233] It seems that, try as they may, those fighting for the railroad were headed for a bust.

In late November 1895, the miners had chosen a new venture to relieve the pressure of the transportation issue. A committee out of Livingston had adopted resolutions at the request of the miners for a better wagon road through the national park to the mines. The *Enterprise* noted that "Congress, in setting apart the National Park and sentimentalists in opposing segregation…has in a great measure isolated these mine owners from the outside world." As a means of rectifying the situation, the committee requested that Congress therefore consider the "appropriation for a passable wagon road to permit wagon freighting of ores and supplies until such time as railroad transportation can be secured."[234]

Again Disappointed

On August 10, 1900, the *Red Lodge Picket* published an article that detailed the sources of two distinct railroad paths into the camp. One route was more advanced—that of the Burlington Northern, which was "pushing its grade work from Taluca in a general southwest direction through Big Horn Basin, touching at Cody and Eagle's Nest, and pointing onward toward Sunlight Basin and Cooke." Cody, Wyoming, lay seventy-five miles southeast of Cooke City. The *Picket* noted that while it was unknown when the connection would occur, it was the "evident intention of the Burlington people" to "strike on through to the coast, skirting along the edge of the National Park," and there was "no apparent possibility of their failing to reach Cooke within a reasonable length of time." The second possible route came from the northeast—the still-in-play Billings route. It seems that a party of surveyors had arrived in Red Lodge; however, it was acquiesced, by those who talked with the party that the gentlemen were "exceedingly

uncommunicative in regard to the work upon which they are engaged." Even so, the *Picket* strongly believed that there was "no question but that they are about to survey a prospective line to Cooke along the Clarke Fork route." This route would start at Bridger, nearly one hundred miles away, where it could connect with the Northern Pacific. It seems this path would exclude Red Lodge, but the *Picket* was proud to say that the city would "not play the baby act and set up a howl of 'sour grapes,'" as it would "be sufficient for Red Lodge to rejoice in the general development of this section of the state." It was believed that the Bear Creek coal mines would find the outlet to Cooke City valuable indeed, and as such, Red Lodge would be positively affected. Red Lodge's faith in the "survey party" seemed absolute, regardless of the sparse information they could relate. Their inside scoop stated that "the reliability of the project comes from the well known fact that Mr. Hall [one of the surveyors] not long ago made an agreement with the principal owners of claims in Cooke that he was to have half interest in all of their claims, provided he gets a railroad into Cooke within four years."[235]

Within two months, the *Picket* would announce that F.A. Hall had succeeded in interesting eastern capitalists in a "stupendous undertaking" based on his findings with the survey team.[236] On October 19, 1900, the Yellowstone Park Railroad Company was formed with capital of $2,500,000. It was stated that the company had "power to build railroads through the Yellowstone Park," although the main route would come up the Clarks Fork.[237] On January 31, 1901, the *Big Timber Pioneer* published a lengthy article on the railroad venture that stated: "work [was] to be commenced in the early spring and pursued through to completion." It had been falsely reported elsewhere that the grading had been completed—a mistake which was only a predecessor to the *Pioneer*'s claim that the road would be "pursued through to completion." The article did clearly state the difficulties to be encountered with this route, which included "an immense box canyon about ten miles in length and 1,500 feet deep" that would send the railroad east to avoid construction issues. This would place the road across Dead Indian Hill, about "1,500 feet above the river," which would be a complicated procedure in itself.[238] The paper mentioned Major Eaton, former U.S. Surveyor General for Montana, among the projectors of this railroad and stated that while the Burlington was interested in pushing forth the route from Cody, the Northern Pacific was just as interested. A progression of events in the spring would determine the route; however, no development from either direction ever came. On February 14, 1901, a mere month after such optimistic portrayals of the railroad, it was reported

"from reliable information" that the "railroad project of Frank A. Hall has been practically abandoned, and Cooke City residents, it is probably, will not see the much needed railroad line to their camp for some little time to come." The cause of this abandonment was noted as such: "Mr. Hall was unable to interest stockholders in the proposed line, and the Burlington and other lines interested have agreed that the project will not materialize and that operations looking to that end are off for the present."[239] All prospective routes were, in effect, put on hold. The next day, the *Red Lodge Picket* published a lengthy article titled "Again Disappointed" that detailed the issues faced by Hall, the railroads and Cooke City. The disappointment felt by the miners was not created by their own failings—as noted by the paper, Hall's plan had failed "in spite of the fact that the expectant miners of Cooke City gave him all the inducements that any man could expect, to encourage him in getting a railroad into that camp." The article stated that "some of them [the miners] placed great reliance in his [Hall's] assertions of his ability to bring them what they wanted," and while others "rather looked askance," it seems that all "were so anxious to see a railroad come their way that they commonly consented to deed to Hall a half interest in all their claims provided he was successful in getting a railroad into Cooke within" an allotted time. With such promise, the miners had anxiously been awaiting progress in the spring of 1901. Hall's scheme would never go further than a "tissue paper road," to the great disappointment of all—a feeling the miners knew all too well. As noted by the *Picket*, Hall's scheme was "only another irresponsible, chimerical, will-o'-the-wisp aircastle that has remained even longer than its foundation gave warrant for believing."[240]

In October 1901, the *Bozeman Chronicle* spoke to a Cooke City miner named McCarthy, who stated: "there has been little change at Cooke, the ore is there and it is rich, but the cost of transportation keeps back the development. We have given up hope of Frank Hall's bringing a railroad there, but believe that the camp will be greatly benefitted by the construction of the new road which has been begun in the Park."[241] The road mentioned through the park would be for wagon travel and would reduce transportation costs by half. The *Red Lodge Picket* reprinted this article with the heading: "Great Camp Noketchem Railroad Yet." The fight was far from over, no matter how many times the outcome repeated itself. In fact, it would appear that Hall still wasn't done. In December 1901, the *Big Timber Pioneer* reported that he had "not yet given up hopes of accomplishing his purpose and feels confident that it will not be a great while until the road is built."[242] Any further attempts by Hall to enlist capital seem to have fallen short, however, and little would be heard from him again.

Good Times at Cooke

February 1902 showed new companies forming in the district, including the National Park Gold Mining Company, which included Colonel David Noble. While visiting Great Falls, Noble gave his opinions as to the future of the camp: "Cooke City will be all right, we expect the Burlington to build our way some time during the coming summer, and at present the government is building an excellent wagon road into the district for the traffic." Noble went on to state that "the camp will yet be a record breaker" and that he was "satisfied to have pitched" his tent there.[243]

The Burlington route, as mentioned by Noble and noted in the *Butte Intermountain*, was not the only route discussed that year. "Business men and old timers of Sweetgrass" had begun promoting their own scheme, an electric line from Big Timber that would be powered by "the waters of the Boulder river." This scheme had been brought to the attention of eastern capitalists out of Baltimore who were planning to have experts "look over the field." The promoters had in mind a plan to erect a smelting plant near Big Timber that would also be run by the waters of the Boulder to care for the ore coming out of Cooke City. It was understood that an electric line of this sort could handle the heavy grades on the path to Cooke City better than a steam road.[244] The *Big Timber Pioneer* reported that a Mr. Cowles from Boulder had recently spent time in the East talking with capitalists who "were so favorably impressed" with the electric line plan that they were "willing to investigate it and if feasible" were "ready to put up the money for construction provided the parties who are now working on it abandon it."[245]

Meanwhile, a route from Bridger was again taking shape. The *Post* noted that "the prospects for a railroad for Sunlight and Cooke City are very bright," coming on the tail of a big strike of copper ore having been discovered about halfway between the two points. It was reported that over 150 miners were working in that area and that the advent of a railroad was "the only thing needful at the present, to set the ball in motion, as the passenger traffic over the line the first year of its use would more than pay for its construction."[246] Over eighty miles west of Bridger, surveyors arrived in Big Timber in August 1902. Led by J.H. Heyor, a practical civil engineer, the party headed for Cooke City, where they would begin their survey of a route to Big Timber.[247] The party planned to be out in the field until November working on the project. The eastern capitalists interested in the scheme had already sent experts to the various mine locations in the area to confirm the bodies of iron and coal to be found there. The reports were

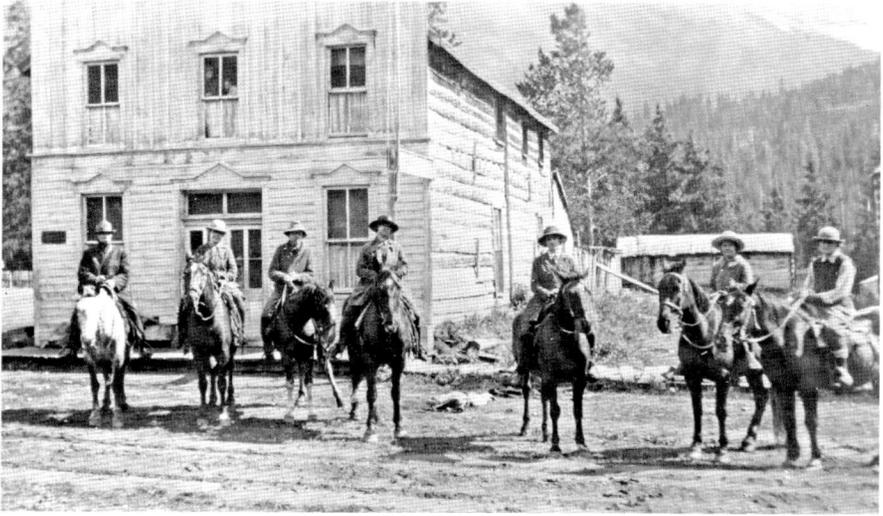

Tourists on horseback in front of the Curl House. *Yellowstone Gateway Museum of Park County, 2006.044.5103.*

favorable on that account. The *Pioneer* noted that "financial success from the outset goes without question." The route of the railroad was littered with "immense bodies of coal, lime rock, sandstone (the finest building stone in Montana) and iron ore, besides immense forests of the finest timber."[248] Such resources would provide thousands of tons of freight for the rail as well as employment for a substantial amount of men. On September 12 it was reported that the party of surveyors had gone as far as Lake Abundance, about ten miles from Cooke City. On September 19, it was noted in a Big Timber dispatch that the party was then thirty miles from Cooke City, taking the route "south of Fisher Mountain, up Slough Creek to the divide, and thence down the east branch of the Boulder river."[249] On October 16, the *Big Timber Pioneer* announced that the survey had been completed. It was reported that the party had "found a comparatively easy route with no heavy grades and the distance was much less than expected, being but 69.87 miles from Big Timber to Cooke City."[250] Many newspapers were reporting "good times at Cooke" as the promise of a railroad brought on a boom of mining activity.[251] This activity would continue throughout the following year as further investigation continued on the two opposing railroad routes out of Big Timber and Bridger.

LIFE LIVED IN WAITING AT COOKE CITY

THE COMING DENVER OF THE STATE

It was still a relatively recent discovery when, in 1889, the *Helena Independent* stated that the Alice E. mine was "pronounced the greatest mining proposition ever known" with ore running $28 to $38 a ton in gold.[252] By the summer of 1892, all were keeping tabs on activity at the Alice E. when a new cyanide mill was constructed—the first of its type in the district—by the Henderson Mountain Mining and Milling Company. The enterprising Thomas Blackhart had been a part-owner of the mine when, in 1891, he died from an accidental gunshot wound in Colorado.[253] The Henderson Mountain Company was leasing the mine for three years and six months, and both William Nichols and George Chittenden were officers in the company.[254] Nichols had spent time in the east making arrangements for the machinery necessary for the cyanide process. It was claimed that such a process, if run successfully, would allow many of the mines to be worked without railroad transportation.[255] In August, the company had acquired a contract for "three six-horse freight outfits" to haul lumber to be used in the process.[256] The equipment for the mill was delayed in mid-September by a wreck on the Chicago, Milwaukee and St. Paul Railroad,[257] and it was not until late October that the machinery would be "put up" by the company at the mill site with a projected operation start-up date no later than January 1.[258] The mill would not actually begin operations until mid-January, when,

with a force of twenty-eight men, the mill would treat thirty to forty tons of ore daily.[259] In March 1893, it was reported by the *Livingston Post* that the product from a sixteen-day run at the mill was $6,000 worth in gold, and that while it was not yet in the shape of a brick, it had been shipped to the U.S. mint in Omaha, and the $6,000 was to be sent to the Livingston National Bank following an assay check.[260] The *Bozeman Courier* reported that the mill was estimated to turn out "$1,000 a day, while the expenses are not far above $100 a day,"[261] while the *Post* declared that between 90 to 95 percent of the gold had been saved in the process.[262] The company planned to accumulate a gold brick worth $12,000 to place on exhibition at the Livingston bank, which would bear the inscription:

> *This brick was reduced from the ores of Cooke City, Montana, the coming Denver of the state. Development of the camp has been immeasurably retarded, and its sturdy miners reduced to penury by failure of the United States congress to grant the common request of the people of Montana for the passage of the bill segregating a small portion of the northeast corner of the Yellowstone National park so as to permit of a railroad being constructed to the mountain fastnesses of the richest mineral camp in the state of Montana.*[263]

By April 1893, four forty-pound bricks had left the cyanide mill,[264] and arrangements had been made to improve the blower on the mill for better performance. The large amount of publicity surrounding the mill and its successful operation no doubt interested a new group of investors and added flames to the burnt-out discussion of the railroad. By October, however, it was reported that the Henderson company had stopped the cyanide mill in Cooke City despite successful runs. It was noted that "Cooke has been unfortunate in having men of no capital to run one of the greatest enterprises ever undertaken here. Both capital and capacity are required."[265]

Due to the heavy winter snow of 1893–94, improvements had to be made by the Henderson Mountain Mining and Milling Company that included the rebuilding of the drum house, which had given way during the winter,[266] as well as new brick coverings for both the engine and boiler.[267] The Alice E. had been readied by early May for operations, but with a great deal of snow still remaining on the mountains, the tunnels had to be dug out. It would seem there were big plans for the cyanide mill that had ceased running the year before. An engineer from Butte was brought in to construct four extra tanks for the mill, which gave a "leaching capacity of from 65 to 70 tons

of ore daily," and preparations were made to accommodate both wet and dry processes.[268] By June, new machinery for the mill had been brought in and set up along with a new dryer.[269] The previous May, a dryer had been delivered at the mill that weighed 20,000 pounds.[270] Getting such equipment to the camp must have taken some determination and a persistent patience regarding the changing road conditions.

In the spring of 1895, reports show an increase in activity in the mining camp. The Henderson Mountain and Milling Company had been switched out for the Blandon Mining and Milling Company in the operations at the cyanide mill and Alice E. mine. The Daisy mine, owned by Harry Gassert, among others, had been bonded to Aaron P. Bliss of Michigan sometime in 1894, with the bonders having big plans for the mine's operations. It was reported that an agent of Bliss, Dr. N. Lehnen, had ordered that a blacksmith shop and a boardinghouse be erected at the camp, while the new investors were planning on spending $2,500 on the road to Cooke City to put it into shape for the transportation of ore from the mine. At the time, it was estimated that over "40,000 worth of ore" lay on the Daisy dump.[271]

The Daisy mine had been partly owned by Harry Gassert, who, in mid-February 1896, died suddenly from appendicitis while in the care of Dr. Alton. At the time of his death, Gassert was about sixty years old and had recently married his late wife's niece; together, they had one son named Adam. Harry Gassert and his partner Jacob Redding had made between $100,000 and $125,000 upon selling the Blue Bird mine in Butte before making their way to Cooke City in 1884.[272] Less than a year after Harry Gassert passed away, Redding also died. The *Standard* gave an account of his life, which surely surprised many who had known the man: "born in Luxemberg, Germany, in 1817, as a young man he traveled extensively on the continent, residing in Paris some time, and afterwards he saw Napoleon." The article went on to note that he had also spent time in New York, Kansas and Colorado before he made his fortune in Butte and joined forces with Gassert. Redding had no heirs to a $150,000 estate, with the *Standard* mentioning that he had "intended to make a will in favor of Adam Gassert" but that it was unclear if such a paper had been executed.[273] Immediately after his death, his cabin was ransacked, with the will supposedly among the papers stolen.[274] A year later, the matter still had not been settled, even though a paper had been found in a tunnel near Cinnabar in mid-February 1897 that appeared to be in Redding's hand leaving most of his estate to Adam Gassert. It is unclear how the story ended, but it goes to show the difficulty of the legal process in an isolated mining camp.

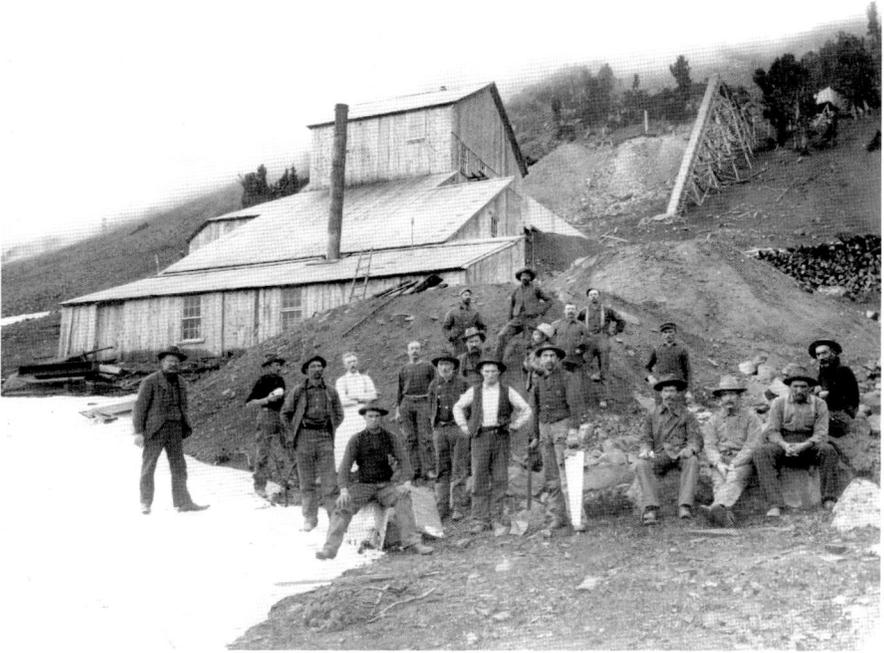

Miners at the Daisy mine. *Cooke City Montana Museum.*

It was reported that twenty-five men had stayed at work on the Daisy mine over the winter of 1895–96 storing ore.[275] In December 1896, the *Standard* published a special correspondence from Bozeman that detailed a recent interview with George Fisher. The fifty-one-year-old miner gave an account of the goings-on at the district, in particular the recent successes of the Daisy mine. It was stated that the ore from the Daisy mine had been shipped to Omaha "at a great expense," which was detailed thus: "it cost considerable to mine it, after which $5 per ton must be paid for freighting the ore to Cooke, $20 per ton more places it upon the cars at Cinnabar, $17 per ton is necessary to lay it down in Omaha, where the smelting must be paid for." In total, it cost about $70 per ton before a profit could be made, and while the article did not say the worth of the ore, it would be assumed that a profit had indeed been made to make such costs worthwhile. The article concluded, "it is these excessive freight rates which have kept back the development of Cooke, where no less than 2,700 mines have been located since the camp was first started in 1872, but the rich strike in the Daisy is

bringing still nearer the day when Cooke must have a railroad and with the railroad smelters of its own."[276] By August 1897, there was another surge of activity at the Daisy mine. The *Big Timber Pioneer* reported that twenty wood choppers had been sent to cut 1,500 cords of wood for the mine.[277] The next week, the *Standard* announced that an ore body had been encountered at eight hundred feet and that "all Cooke is jubilant over the strike, as this is regarded as the pivotal point in the camp's history."[278] It was also during this time when talk of a local newspaper surfaced. It was to be called the *Mining Recorder* and was to be run by Mr. Hays of Red Lodge, with the first installment to be available within six weeks of the announcement. Such a newspaper, unfortunately, has never been located.[279]

Regardless of a deep snow, the Daisy mine was expecting a big year in 1897, with Mr. Jurgens announcing that the mine was indeed using the new electric drill, which he believed would soon do away with the air drill. He proudly stated that his drills "are the only ones of that kind being used in the Cooke City district."[280] Jurgens's optimism was justified in September, when a thirty-foot-wide lead containing wire gold that was "plainly visible to the naked eye" was struck. The *Red Lodge Picket* smugly wrote: "Cooke will now take her place as one of the greatest mining camps on earth and we congratulate the old-timers who have loyally stood by her for half a life-time patiently bearing the gibes and jests of those who are ever ready to exploit their ideas on subjects they know nothing about. All hail to Cooke!"[281]

A letter from Cooke City states that the "snow from that camp to the Daisy mine, 3 ½ miles, has just been shoveled from the road and that the machinery for the ten-stamp mill is being hauled up to the mine. Eight six-horse teams have already arrived at Co[o]ke loaded with the machinery and two car loads more are ready to be freighted in." With such activity, the 1898 season began. It was also noted in the *Red Lodge Picket* that "over forty thousand feet of lumber" had been sawed by E.C. Kersey for construction of mill buildings around the mine, and there was a boom in employment as "all men at Cooke who will work"—plus fifty more—were put on at the mine.[282] This boom was short-lived, however, and the operation soon slowed. By the fall of 1899, development work on the mines had continued at a hearty pace, but production was at a minimum. The cyanide plant was not running, nor was the Republic smelter, while the Daisy mill was hardly operational. The Republic outfit was in need of a proper manager to continue work, and all were contending with the issue of breaking down the ore enough for shipment.[283] Of course, this meant that transportation was still an overwhelming problem for the camp.

ON TO COOKE!

With the start of the twentieth century, a new wave of mining industrialists swept through the area. One of them was Dr. G.L. Tanzer of Seattle, Washington. In 1904, he was the president and treasurer of the New World Smelting Company, which was about to start the largest mining operation ever undertaken in the area.

It was noted that by September of the following year, a smelter, sawmill and five-mile-long road would be in place, as well as the development of a small townsite.[284] On November 19, 1904, it was announced that the company was going to publish a seven-column paper titled "The New World City Times" in the interests of the New World Mining District. It was to be published weekly out of New World City in Park County, Montana. Only one edition has survived to the current era, making it difficult to determine if the paper was indeed published weekly.[285]

By the end of 1904, the *Gardiner Wonderland* optimistically related: "old mines that have lain idle for years are being developed…new business is springing up, new men put to work and a general awakening is going on. On

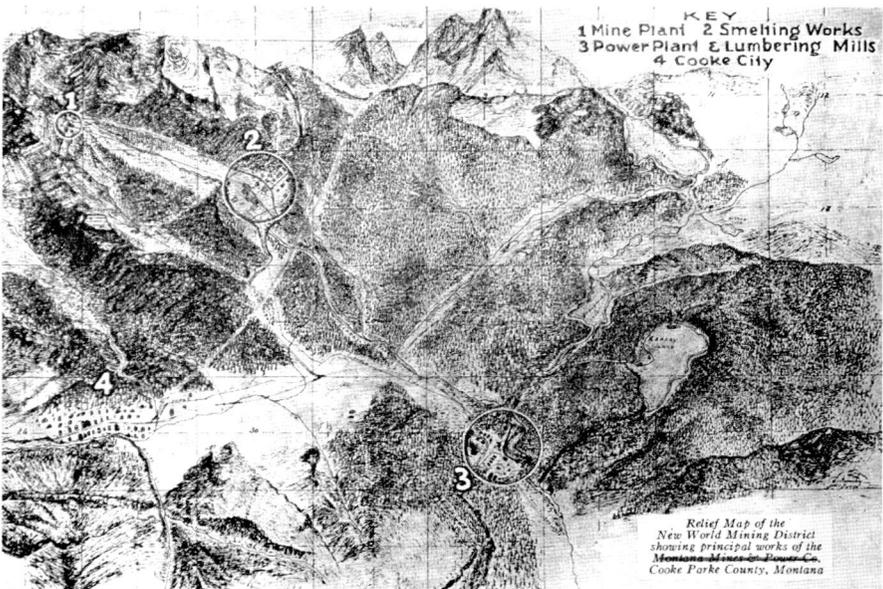

Relief map of the New World Mining District as printed in promotional materials for the Western Power and Smelting Company. The mine plant, smelting works, lumber mills and Cooke City are marked. *Cooke City Montana Museum.*

New World City Times

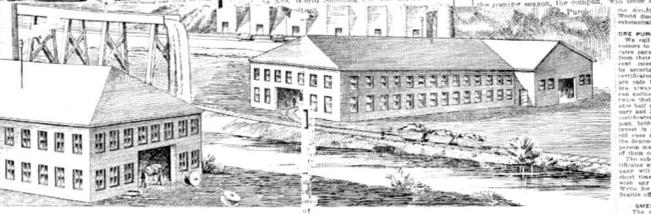

New World City Times, New World City, Montana, November 25, 1904, showing the companies' planned operations. This was the only edition printed. *Cooke City Montana Museum.*

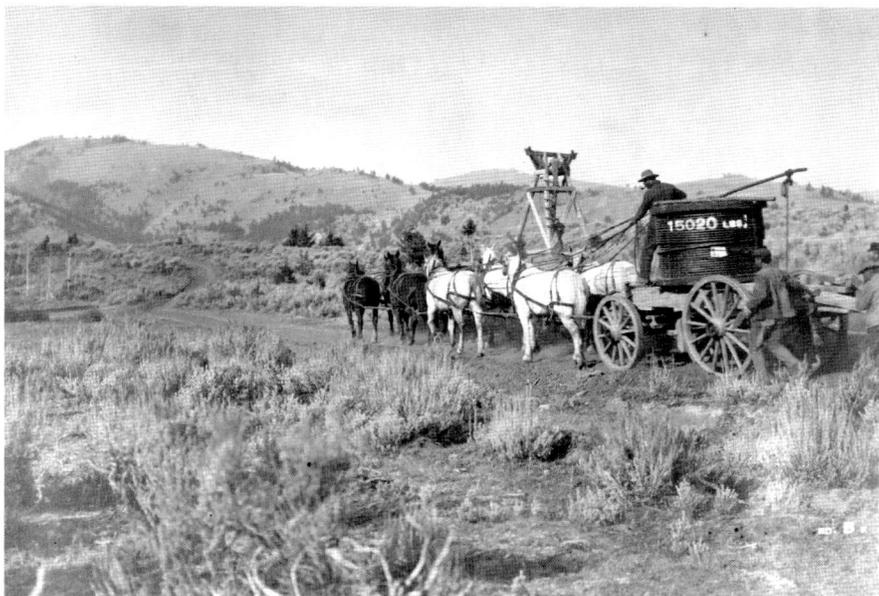

Transporting the tramline from Aldridge to Cooke City to be used in G.L. Tanzer's operations for the Western Power and Smelting Company. *Yellowstone Gateway Museum of Park County, 2006.044.0061.*

to Cooke!"[286] It was the old Republic smelter, however, that gained notoriety in 1906, when "the first blast of a smelter whistle blown in 20 years" signaled that operations in camp had resumed.[287]

News was scant about the mining operations during the next decade as the battle for a railroad reignited. It wouldn't be until after World War I that Tanzer and mining operations in general picked up again. At this point, Tanzer had constructed a power plant run by a flume and waterfall near present-day Colter Pass. He had purchased a tramline from Aldridge, Montana, to repurpose in his operations.

While everything was at the ready, Tanzer's sudden death in Germany in 1927 put the company is disarray. Many assumed that he had absconded with investment funds, but since he expended money on physical equipment, that assumption is unlikely. Most of the equipment sat unused in the smelter for years to come.

By 1920, things were rapidly changing in the little valley. Most notably, there were outsiders interested in the landscape, the people and—for the first time—the history of the area. For many, this was a golden era. The old-timers were celebrated in August at the annual fish fry, an event that

served as a gathering for those who left for the warmer west coast or headed south for the winter. It also served as a venue for the retelling of stories that had turned the corner into the past. This caught the attention of magazines and newspapers, which seemed to be in a rush to document the "old west." While the bulk of this occurred in the '20s and '30s, the *Livingston Enterprise* had been the first to use the term "history" in its turn-of-the-century special edition titled "History of Park County." The paper discussed the history of various locations in Park County and provided biographies of its prominent citizens. It was proclaimed that the New World Mining District was "among the greatest possible mining camps in the world today." (Note the word "possible.") The section on Cooke City, while applauding the mining industry's successes thus far, focused on the lack of economic transportation. Readers surely saw potential in the mines of Cooke that had yet to come to fruition—the "possible" prospects. It was this hope that would carry Cooke City throughout the next few decades of boom and bust. The type of ore found in the district was also an item of interest in the *Enterprise* article. It was characterized as predominately "silver-bearing galena ore" varying "through every gradation of class and richness," although some free-milling quartz did abound in "a number of locations, some of it rich in gold." This meant that while the district was "principally silver bearing," it was "by no means entirely so," allowing for speculation as to its rank in the production of gold, "the more precious metal." The *Enterprise* called Cooke City the central camp "acting as the axle to a wheel-of-fortune" with spokes of rich mineral veins surrounding it in every direction.[288] A wheel-of-fortune, indeed; while some left Cooke with wealth in their pockets, and some lived in peace getting by with just enough to be comfortable, there were still more who lived through each endless day of waiting for the big strike in a struggle for survival.

He Might Strike It Still

Those years of waiting were, for many, filled with the daily work of digging and the daily work of living. In 1923, the *Denver Post* looked at the history of Cooke City via a couple of notes about those who were still in the camp waiting for another boom. The article, written by Cody local Caroline Lockhart, noted that "Mr. and Mrs. Anton Zukor [*sic*] live in a cabin in the tall timber on the side of a mountain" and that "the roof is ready to fall in

about their ears, but they have little time to fix it, they've got to get to the ore that they feel sure lies somewhere in the mountain." In 1923, the Zuckers had a 250-foot tunnel to show for their efforts, and Lockhart explained that "it has taken them twenty-five years and they have made great sacrifices and endured incredible hardship, but with unswerving faith in their ultimate success they toil on, old, crippled, and not too much to eat sometimes." It is likely the Zuckers (misspelled by Lockhart) had actually been located at Cooke for over thirty years, with their arrival occurring sometime in the early 1890s. The tunnel would have been driven almost ten feet per year by hand. The paper quoted the couple, with Anton stating "Yes, it is quite hardt" in his "broken English," while his wife "grimly" added "but we've got to get to the ore, Anton, we can't stop now, can we?"[289]

Both Anton and his wife, Anastazie, were Bohemian immigrants who had come to America in the mid-1880s. On March 31, 1884, Anton had arrived in New York on the *Jon Breydel*, a German passenger ship that departed from Antwerp, Belgium.[290] He was twenty-four years old. Anastazie immigrated in 1887 at the age of about thirty. While it is unclear if Anton and Anastazie met prior to their separate immigrations, they were married by the early 1890s, and by 1900, they were living in Cooke City, as recorded by the Census.[291] Their story was often retold, as it was the epitome of existing on hope and the grace and mercy that they could not see the future. In 1917, Gertrude A. Zerr wrote a similar article for *Sunset Magazine* detailing life in the camp, although it was less about the truth and more about the symbolic forgotten Western town. In it, Cooke City was renamed "Lost Lode," possibly to protect the town from scrutiny, or possibly because the name sounded loftier on the tongue. Without giving a name, Zerr mentioned "an old couple" who had "worked and dug for thirty years" at their mine. The similarities were there between this couple and the Zuckers, however, the words Zerr placed in Anastazie's mouth sound more like her own than Anastazie's. Zerr noted that the couple "worked by hand, carrying the ore out in baskets because there was no money for machinery or cars." To make ends meet, they did "odd jobs for the other miners and their wives, to get money for dynamite and food." According to Zerr, Anastazie had "never picked a berry to put up for the winter." Her reasoning, as quoted by Zerr, was: "Why should I? By the winter time we will have our fortune and I can buy all the tame berries I want." Zerr went on to state, "She [Anastazie] expects to travel, to wear good clothes, and to go into society" and that she "corresponds with beauty editors, and keeps her complexion marvelously good." Because of her Bohemian upbringing, Zerr notes that Anastazie "engages the ever-departing teachers to come back

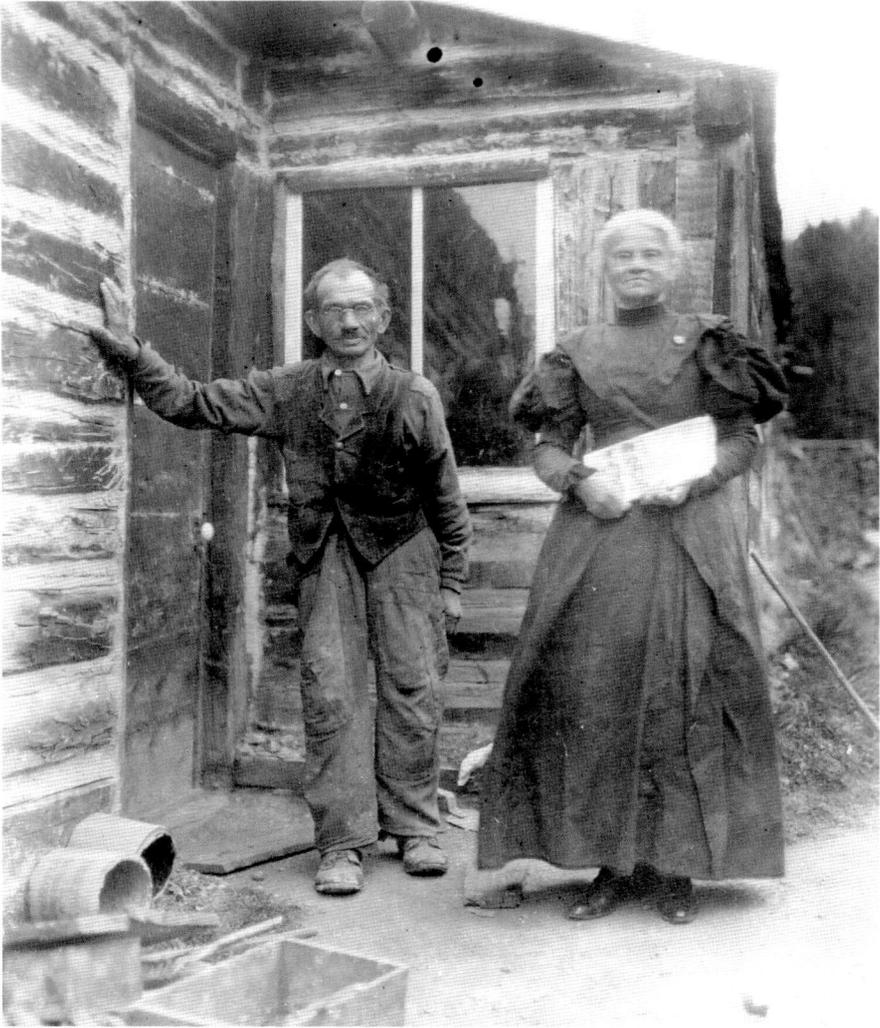

Anton and Anastazie Zucker at their cabin. *Cooke City Montana Museum.*

when the railroad is built and teach her good English." Zerr's carefully curated picture of the Zuckers ended with Anastazie dramatically crying out, "They will take us to the poorhouse and let us die, when if we stayed we would be rich. But I will never go. If the railroad does not come in time, I will kill myself before they shall take me!"[292] The image of stubborn resilience against what time had made of them was complete.

However, letters Anastazie wrote in the mid- to late 1920s paint a more honest picture of the couple. On November 16, 1925, Anastazie wrote a letter to Isobel Holland, a girl who had grown up in Cooke City and since moved to another town. Her letter begins: "A question if I am still at Cooke—I surely have to stay at Cooke my Husband has done here so much work on his Claims that we can't leave Cooke anymore although he has not strike [sic] the ore yet. I am very lonesome being so far remote of all civilization but I have to stay as long as he is able to work he might strike it still." While it is possible that age had tamed the woman Zerr supposedly quoted, this letter does not suggest a woman who is blind to the truth, one who would not pick berries because wealth was on its way. The letter shows a woman who clearly sees her life as it is but maintains hope that "he might strike it still." Her letter continues to discuss the economic and social climate of Cooke:

> I not wonder to you that you are longing to be back in Cooke. It was that time a Virgin Place where you were born and there was more People at Cooke at that time than it is now....For Summer there come quite a few visitors a specially [sic] when the Picnic occur [sic]...if some Company would start some real work there wou[l]d be more life at Cooke, of course I mean for young folks, but I wish to be out of Cooke.[293]

Again, her assertion that she wishes to leave seems incongruous with the hysterical image presented by Zerr of a woman who would rather kill herself then leave without striking it rich. It is also interesting to note her mention of the summer visitors, as this is just about the time period when tourism began to become a strong economic force for the community. During the 1920s, the annual Picnic in August brought in a surge of visitors who wished to see the old mining camp and enjoy the recreational benefits of the surrounding wilderness. In the 1920s, the Northern Pacific produced a short silent film that included a few shots of the picnic festivities. In one scene, Anastazie Zucker is talking to another woman, then notices the camera and looks over to give a quick smile before continuing her conversation. This, along with images of the couple at their home (presumably taken during one of the previously mentioned interviews) and the letters, allows a rare glimpse of life beyond the words of a reporter. Anastazie Zucker's letter ends with a very human note: "I thank heartily for your friendliness I don't desire anything, unless in the next fall a good sweet Washington Plums. I would bake Plum Dumplings."[294] Lockhart's and Zerr's images of a stubborn and

Cooke Mont. Nov 16. 1925

My dear friend Isobel!

I have been very pleasantly surprised of Your longing and kind Letter which I received oct 30th a question if I am still at Cooke I surely have to stay at Cooke My Husband has done here so much work on his claims that we can't leave Cooke any more although he has not strike the ore yet. I am very lonsome being so far remotes of all civilisation. but I have to stay as long as he is able to work he might strike it still, in our place is always gold & Silver assays of course in a small quantity as yet.

I not wonder to you that you are longing to be back in Cooke. It was that time at Virgins Place where you were born. and there was more People at Cooke at that time than it is now.

In Summer there come quite a few Visitors a specialy when the Picnic occur. If may be that the coming summer be more lively it is said that the glengary Company use to be Leah Bonet is intending to put a new Smelter, I guess they are having there a Copper ore — if some Company would start some real work there would be more life at Cooke — of course I mean for young Folks. but I wish to be out of Cooke.

I have never seen Arly's Wife but she is surely a fine Lady if she is good to her Husband convey to them my hearty greetings.

I remember well Maude & Lawrence Macumber, I did like them too. and Mrs Maggie Herr, convey my greetings to them also.

Left: Letter from Anastazie Zucker to Isobel Holland dated November 16, 1925. *Cooke City Montana Museum.*

Below: Crowd gathered on the steps of the Cooke City Store. Hoosiers Bungalow is across the street, and the Cosmopolitan Hotel is in the distance. *Cooke City Montana Museum.*

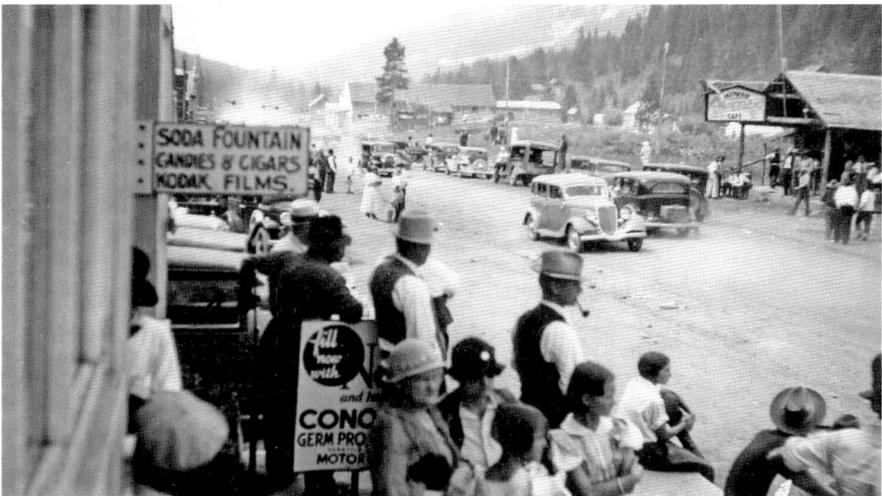

110

unrealistic woman seem too stereotypical, too minimal, for the complex character of Anastazie Zucker.

On August 27, 1934, at 7:00 a.m., Anton passed away in Livingston after a bout with bronchitis that had been followed by pulmonary edema. He was buried the next day in the Mountain View cemetery, leaving Anastazie a widow in a rugged landscape. Within a year of his death, Anastazie was taken to the Montana State Hospital in Warm Springs in Deer Lodge County. In 1940, the *Choteau Acantha* told the story thus: "County charges in their last years, the old man died one day, and it was not long until his wife was taken to the state hospital, a veil of mercy enshrouding her memory in her last days."[295] On October 25, 1936, Anastazie Zucker died and was buried on October 28 in Warm Springs, nearly 250 miles from where she had spent a majority of her life and over 5,000 miles from where she was born. Together, she and Anton lived and died their mountain valley dream.

At the start of the twentieth century, however, hopes had been high. A column printed in the *Red Lodge Picket* on August 17, 1900, titled "Cooke City Gleanings," contained several updates on the mining activity at Cooke. It seems the camp was busy enough for Nick Tredennick and a man named Collins to open an assay office, where it was noted they were "doing a large amount of" business.[296] By September, it was also noted that things had "changed wonderfully in Cooke City during the summer" as "men who, during the early spring, would have sold out for a song, are now holding their claims in the hope of getting thousands of dollars for them." This boom had no doubt been brought on by Tanzer's operations. Regardless of these uplifting prospects, at the "first approach of winter, in the shape of several inches of snow" the summer miners left the camp in their annual exodus.[297] Even with the loss of the summer population, it was apparent that the ideas set in motion that year would carry them all forward. As the *Red Lodge Picket* proclaimed: "Have courage Cooke, the fruition of long cherished hopes seems almost within your eager grasp."[298] The Zuckers, no doubt, held onto that hope; there was a railroad in sight.

LAST PUSH FOR A RAILROAD

THE CHANCES FOR A RAILROAD...ARE SOMEWHAT REMOTE

"Cooke City will be all right," said Mr. Noble today in speaking of the outlook. "We expect the Burlington to build our way some time during the coming summer, and at present the government is building an excellent wagon road into the district for the traffic. The camp will yet be a record breaker and I am satisfied to have pitched my tent there." [299]

At this point, many of the men who had first arrived in the valley during the initial discovery period were in their later years. Local personalities like Jack Allen had begun to winter where the climate was less harsh. Allen had sold a portion of his business at Cooke City, spending more time in the surrounding communities.[300] In 1903, Horn Miller's cohort "Pike" Moore passed away at seventy years of age.[301]

Martin Ranmael, who once delivered the mail to Cooke City by way of Nye, was noted in 1904 as saying a "first-class wagon road" was all that Cooke needed to bring its goods to market at half the current transportation costs.[302] It appears that hope had again returned to those who were still holding interests in the Cooke City mining area. The Precious Metals Company had ordered two smelters and a sawmill, which were to arrive in the summer of 1904. The equipment would arrive in Gardiner by rail,

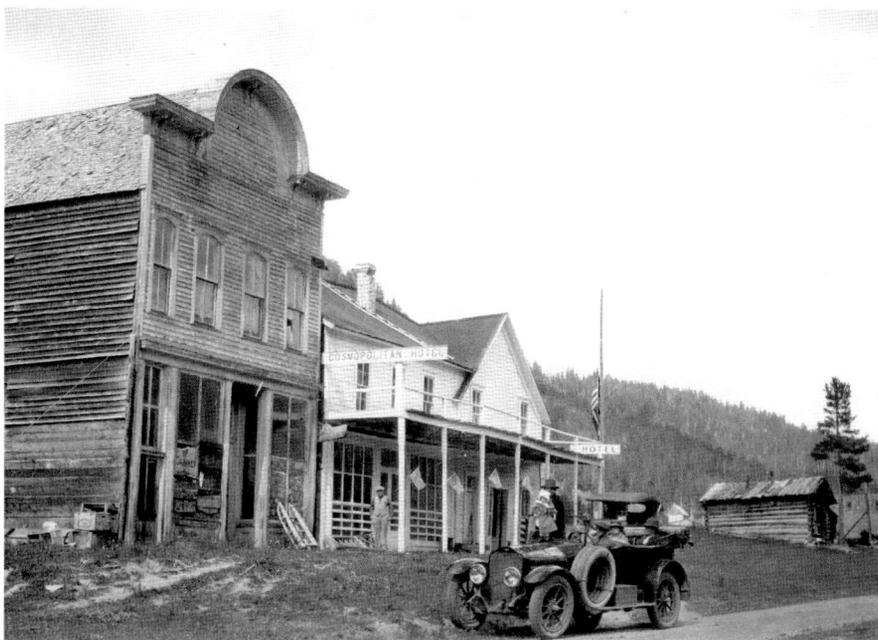

Cosmopolitan Hotel with Jack Allen standing on the porch. *Cooke City Montana Museum.*

traveling the remainder on wagon roads.[303] Concurrently, Tanzer was making preparations for his own operations, which would include a smelter, sawmill and townsite.[304] Years passed following this revival of high hopes and dashed dreams, as had always been the story of Cooke City.

While most business during the next decade was carried out by way of the Yellowstone Park wagon route, the renewed vitality of the mining district brought on a renewed interest in a railroad as well as the first hints of a new industry: tourism. In 1917, the *Ronan Pioneer* published an article by Lieutenant Governor W.W. McDowell, who had visited Cooke by way of the national park. His idea was to make Cooke City an entrance to the park with a connection to the Milwaukee Railroad via the Stillwater and Billings. McDowell proclaimed: "it would make, in my opinion, the most impressive entrance to the park possessed by any of the railroads."[305] This idea would be mirrored by the "Black and White Trail Boosters," who, led by Dr. J.O. Siegfreidt, were promoting the building of a road from Red Lodge to Cooke City. This plan would, in time, lead to the construction of the Beartooth Highway.

Early view of the Beartooth Highway on the Red Lodge side. *Gallatin Historical Society/ Gallatin History Museum.*

While such a route would be an option for the transportation of ore, it was not a railroad route as Cooke City had hoped. Regardless, Robert McKay, a capitalist, spent a reported $35,000 to resurface the road between Cooke City and Gardiner. To improve upon this point, McKay had gained permission to create a "metal surfaced" road from Gardiner to Cooke City that would hold up to more truck traffic.[306] Permission was in the form of a permit reportedly belonging to the Cooke City Transit Company. According to sources, the road was to be started in the summer of 1919 and be completed by fall. However, in January 1919, it was noted by the *Flathead Courier* that the permit had been cancelled by the Secretary of the Interior.[307]

The issue lay dormant until February 1920, when talk of a "metal-surfaced" road began again, this time led by the Livingston Rotary Club. A permit had again been secured by W.D. Marlow, a New York investor. Details of the permit had not yet been disclosed by the Department of the Interior, leading Marlow to arrange for twenty heavy trucks to haul ore out of Cooke City via a resurfaced park road.[308] The engineer in charge of the resurfacing noted that "during the late war it was demonstrated that with a hard-surface highway freight can be hauled for a distance of 80 miles as cheaply with trucks as by rail."[309] However, while preparations were set, Marlow had only recently purchased the Republic Group of mines, and under the contract, he could not ship the ore until an initial payment of $40,000 had been made—a small percentage of the $4 million purchase price.[310] Once the

payment was secured, Marlow only had to wait for the completion of the new road to employ his fleet of one hundred five-ton trucks for carrying the ore. Another ten trucks would bring fuel to the camp in the form of oil and gasoline, and another ten would transport food and supplies. Already, Marlow had employed 160 men in developing the mines.[311] Little was heard about an actual railroad through the park.

Ten Blisters Were Raised

While the Black and White Trail was progressing up from Red Lodge, another feat was accomplished when, in September 1919, a White touring car, a common touring vehicle in the park, made the journey from Cooke City to Cody by way of Sunlight Basin. It was noted that "ten blisters were raised, and a pick, shovel and axe were worn out removing rocks and stumps from the road and filling up mud holes, and once the car had to be tied to a tree to keep it right side up while climbing a sidling hill."[312]

Meanwhile, a railroad scheme was again gaining traction by way of the Stillwater. In December 1921, it was noted in the *Choteau Montanan* that a firm, Ernster & Barker, had arrived to handle all explorations of the plausibility of a railroad, including the quality of ore at Cooke City and questions about a right of way, costs and general feasibility. Hopes were again high for the miners at Cooke City. Between talks of a railroad, a newly surfaced outlet through the park, the proven feasibility of the Sunlight Basin route and the new construction of the road to Red Lodge, they had much about which to be enthusiastic. As noted by the *Choteau Montanan*, "No mining camp in Montana has had a harder struggle against adverse conditions in its efforts to become a producer than Cooke City, and none, it is believed by many mining experts, has brighter hopes."[313]

In October 1922, reports were in from Ernster & Barker's findings. It had been determined that a railroad would be constructed from Columbus to Box Canyon and from there to Lake Abundance. It was then stated that "the chances for the railroad entering Cooke City are somewhat remote" based on the prohibitive cost and available tonnage of ore at Cooke City. The numbers just hadn't added up. Regardless, the road was still touted as the "Cooke City Road."[314]

SO THEY GO ON...

As time passed and Cooke City was in the news more and more due to these events, the public became interested in the people who lived there. Many had passed on, like Horn Miller, who had died in 1917 and was buried in the local cemetery. To many, these men were heroes and martyrs alike. They had struggled in vain waiting for a railroad or adequate transportation out of the valley. They had become legends:

> ...so they go on, living on hope and bacon, dreaming of millions while the logs rot in their cabins and the timbers in their tunnels. Youth has passed, one by one they join the silent company in the barb-wire fenced graveyard on the hillside, yet the survivors remain hanging on somehow, waiting for "capital to take holt," for a railroad, for the something wonderful just around the corner which every human being, subconsciously or otherwise, believes will come to him.[315]

Cooke City in the winter with Republic Mountain encompassed by snow. *Gallatin Historical Society/Gallatin History Museum.*

The railroad never came—despite all attempts, schemes and routes, the iron horse never arrived to aid in the plight of the miners. With the park route blocked by litigation and all other routes implausible due to the terrain and costs, the miners of Cooke were left as they were. Little ore was taken from the valley, and few made it out rich.

10

TOURISM

GUESTS FROM THE LENGTH AND BREADTH OF MONTANA

Cooke City, with its tumbledown houses, old-timers and beautiful landscape, held something intriguing for visitors. While it was surprisingly vibrant during the 1920s, with prospective mining activity at yet another high, it was the lull of its past that brought many to the valley. The annual fish fry began to attract people from the surrounding communities of Gardiner, Livingston, Red Lodge and Cody. In 1927, the town's population was about twenty-five persons year-round with a boom of three hundred and fifty to four hundred in the summer months.[316] Few of the old-timers remained, and fewer still stayed throughout those winter months. As such, they spent time in the surrounding communities spreading tales of the early days of Cooke City. This coincided with a seemingly national interest in the "Old West," and dude ranches began to boom. One was the Nordquist Ranch, located near Sunlight Basin between Cody and Cooke City. Ernest Hemingway became a frequent visitor to the area during this time.

The 1928 fish fry announcement noted that the event had become a statewide attraction that would draw "guests from the length and breadth of Montana."[317] The event was to include music, sports, public speaking, food and pioneer contests. In 1941, it was estimated that five thousand people had attended the twenty-fifth annual festivities that year. To feed

Young girls at a fish fry; the Tredennick girls are among them. *Kathy Kleppinger, Tredennick family.*

the crowd, 1,600 trout were served to an equal amount of dinner guests. According to William W. Thayer, president of the Cooke City Commercial Club, "it was likely the largest crowd ever to attend the event."[318]

An interest in the days of old also inspired recognition for those who had passed on in those early days. Caroline Lockhart, an author out of Cody, pushed for a tablet to commemorate the deaths of Jack Crandall and his partner Doughtery, who had been killed by Native Americans in 1870 while prospecting in the Clarks Fork area.[319] Crandall had inspired Horn Miller to prospect in the valley and was truly the first to suggest the mineral wealth of the Cooke City area.

These early stories were recorded by those interested in the pioneers of Montana, many of whom were grouped into the "Society of Montana Pioneers" throughout the nation. Annual meetings brought the members together to commemorate those lost and recall early exploits. James Gourley, who had arrived with Miller in 1870, was interviewed by Mrs. M.E. Plassmann while en route to a meeting of the Pioneers in 1927. He was eighty-seven years of age. This interview contained the story of initial discovery in the Clarks Fork region, how they had been chased away by a band of Native Americans and how they had made their return to claim the region as their own.[320] These types of stories were repeated time and again in local newspaper articles and even a few national magazines

like *Sunset Magazine* and *True West.* Stories of gunfights, avalanches and the daily life of living in a remote camp thrilled readers hungry for a glimpse into the quickly fading old west.

Golden Boot

A legend began circulating in the late 1920s about a missing boot full of gold that had reportedly been buried in the hills around Cooke City. A weathered stump with a carved cryptogram was said to be the key to the location. It seems that in 1880, two prospectors were making a return trip from Virginia City to the east, having struck it rich. On the trail near Cooke City they were attacked by "gold pirates," although they had taken this dangerous route to avoid possible road agents on the more beaten path. One man was killed, and the other took off his dead partner's boot and filled it with gold and buried it before carving on a tree the clues for its retrieval. According to reports, the cryptogram consisted of an eight-inch circle containing a three-inch cross, the date 1880 and a triangle with the numbers six and five underneath.[321] The boot has never been found, and the stump has since been removed from the area, but the legend remains.

This thrill of the "wild west" also led to a deterioration of the "true west." As noted by the *Big Timber Pioneer* in 1936: "Cooke City is truly one of the last frontiers. But even here false front store buildings and picturesque sod roofed log cabins are giving way to filling stations and rustic though modern lodges."[322]

While the people were an important part of the tourist draw, so was the landscape. The famous Grasshopper Glacier was just a horseback trip away from town, and the views were hard to beat, no matter which direction one chose to approach Cooke City. One can further establish the interest in Cooke City by looking at a reprint of the short-lived 1886 paper, the *Cooke Pic Nic.* Readers, visitors and locals were intrigued by Cooke City, and thus the era of tourism began.

Cooke Pic Nic

G. O. A. O. Publishing Co., November 7, 1886

The latest from Bozeman as explained by Mr. O. Hoskins, this morning, concedes Toole's majority to amount to 2000 "majority." Tate and Mitchell were a tie with Cooke to be heard from which will give Mitchell a small majority

Election passed off very quietly and was a success. Democrats, Republicans and Mugwumps were all on hand. The amount of money expended through the kindness of the represen tatives of both Parties would have made Hogem or many other live cities ashamed of themselves.

Fall fights commenced in Earnest. Nothing serious occurred on the 2ond as our efficient officers were on hand to demand peace.

All differences have been amicably adjusted regardi ng money and feelings, and eternal friendship will reign for the next two years.

The Republic company have discontinued work indefinitely. The roads have been in such a bad condition for the past month that Teamsters were compelled to withdraw from Hauling Ores &c

With this issue Editor and Devil will bid you adieu. A position has been offered us by the Iceberg Company to cook for the winter but as we would have to furnish grub for 10 men we were compel led to decline and will go it on Elk straight. The Iceberg, Bunker Hill, and Shoo Fly Lodes on Miller Mountain are looking well

and work is progressing as fast as Powder and Muscle can push it.

The Citizens of Cooke are taking a lively interest in the Temperance movement. As soon as $5,000.00 can be raised, The Association will commence to improve the ground presented to them by the Woodchoppers and Charcoal Burners Club of Cooke, M. T.

Make Application and have a Deputy U. S. Marshal and a U. S. Commissioner appointed for Cooke. You are bordering on the Crow Indian Reservation, The National Park, Wyoming Territory and are the acknowledged citizens of Gallatin County, M. T.

J. X. Beidler usually called X, has made arrangements with the Norway Government for the purpose of introd using their Crown Patent Snow Shoes. He has sent for two dozen, and has secured the services of Chas. Johnson of Gardiner to educate his assistants in the manly art of snow shoeing. X says it will be necessary, as he will have to herd his herd of Buffalo in the Park all Winter.

What Cooke wants is a R. R. When we get one, Smelters Concentrators and Roa sters will follow. Then she can' prove herself one of the best Mineral belts in the Mountains.

Mitchell, Alderson and Miss Huston were favorites on Nov. 2. Sanborn is a rustler but he found equals on Nov. 2.

X Beidler has sent his Linen Duster to Benton to have it lined and fixed for herding Buffalo and Elk this winter.

Sam Mathers is connected with Pat Hanly at the Headquarters. They are heavy shippers of Spieth & Krugs "a quality unsurpassed" and the celebrated Brands of Whiskies Wines and Cigars. Call and visit the boys.

Joe Wells has opened the Palace Saloon. He has a fine assortment of Impor ted Wines Liquors & Cigars, and is at the helm himself to attend to a Game of Billiards or Cards which is a safe guarantee for the House.

Gassert Black & Co will erect a 40-Ton Smelter next Spring.

There is now 100 Tons of Bullion and enough Ore to pay the National debt awaiting shipment at Cooke.

Cooke not only ackn owledges but appreciates a visit from Tate Imes and Henry. The 3 were the only ones who acknowledged our existence.

No danger of Jim Cutler going broke when he can pound out a $40.00 nugget Daily

Truthful John has got his work in for the next 2 years.

"Cooke Pic Nic" from 1886 as reprinted in the *Bozeman Avant Courier* in 1924. *Gallatin Historical Society/Gallatin History Museum.*

The Best, Newest and Nicest Little City in Montana

The mining industry would ebb and flow as it always had, but economics in Cooke City began to lean toward providing for visitors, not the miner or the capitalist with mining interests. The change in Cooke City was slow, but the needs of tourists were quickly on the rise due to increased automobile traffic, the dude ranch phenomenon and the continued success of Yellowstone National Park. To meet this need, in 1932, it was announced that Park County would soon boast a new town just a few miles west of Cooke City and less than a mile from the park boundary.[323] It was noted that the buildings in this new site could only be of log construction, so clearly, a connection between aesthetics for tourists and the landscape had been drawn. This new town was to be named Silver Gate.

In the summer of 1933, it was announced that A.G. Vincelette had opened up his brand-new cabins in Silver Gate for the tourist season.[324] This opening was perfectly timed, as within two years, the Beartooth Highway was completed, bringing in tourists from both sides to see the park and the new highway. Business boomed, and many other operations started in Silver Gate, including the Gorham Chalet, on which construction began in 1937.

It was noted in the *Fallon County Times* that "every one who has been at Silver Gate exhausts his or her vocabulary in describing the place and says it will be the most popular vacation resort when the new highway leading through to the park is completed."[325] According to John L. Taylor, promoter and conceiver of Silver Gate, it was the "best, newest and nicest little city in Montana."

A note in the *Big Timber Pioneer*, however, forebodes what would be a drawback for local economics. A German magazine was to publish photographs of the new Red Lodge–Cooke City highway, bringing it to the "attention of Herr Hitler and his Nazi citizens."[326] By 1940, most expected a higher visitation rate due to a lack of travel abroad during the coming of World War II.[327] This did not come to be, as gas rationing limited the amount of car trips people could take, thus sending the area into a depression. This was true of most of Montana. In 1942, the Silver Gate Inn, which had been sitting empty, burned to the ground due to an electrical issue, and at the close of the war, Gorham sold the chalet.[328] What started as a booming town had quickly dissipated with the onset of war. The depression, however, was short-lived, and like its neighbor, Cooke City, Silver Gate again boomed.

Road from Cooke City heading west to Silver Gate. *Gallatin Historical Society/Gallatin History Museum.*

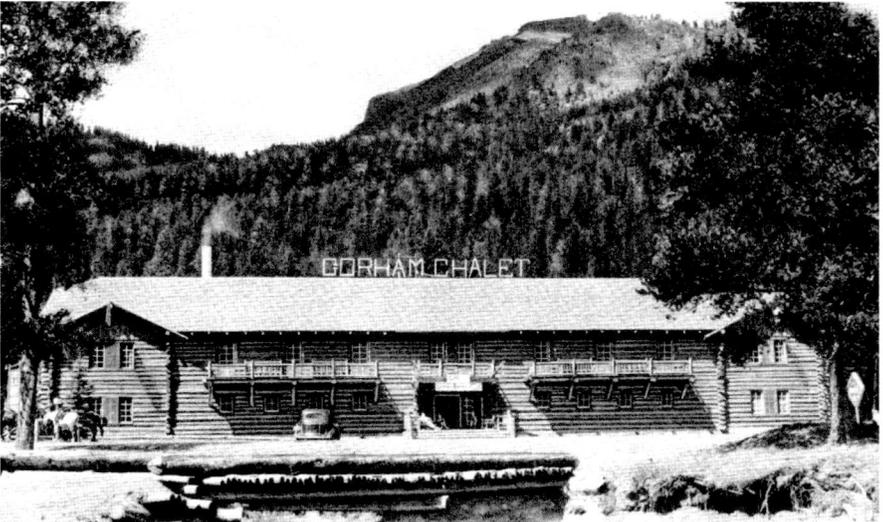

Postcard of the Gorham Chalet in Silver Gate. *Cooke City Montana Museum.*

While Silver Gate was born of tourism, Cooke City took a bit longer to come around to the realization that the tourist trade was the new economic force. As the *Choteau Acantha* put it: "To this region vacationists are coming in increasing numbers to seek a far greater treasure than gold—health and relaxation."[329] During the late 1930s, Cooke City would see a new age in mining activity, tourist traffic and scientific interest in Grasshopper Glacier. This diversifying of economies is what helped Cooke City to last into the present day.

THE REAL PLAY HAS NOT YET BEGUN

Today, Cooke City still survives on ebbs and flows, although they are now steadier and more expected. Spring brings tourists, and the busy summer season sees over 250,000 visitors pass through the same old main street as decades past. Fall offers a brief respite before the snowmobilers and wolf-watchers flood the area for the winter. In recent years, new construction has also been booming as people from across the United States seek a place

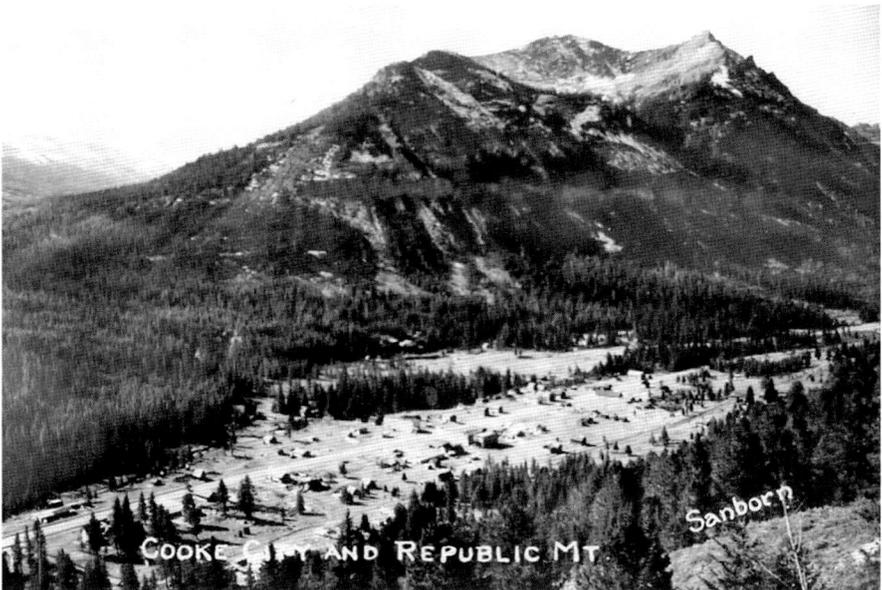

Cooke City and Republic Mountain are shown in this Sanborn image. *Cooke City Montana Museum.*

of beauty and refuge to call their home. The times are ever-changing, but the themes remain the same. It seems everyone in Cooke City is still waiting—waiting for the visitor to come in search of this new gold, the constant beauty to be found in the landscape and the life lived between the mountains.

> *Perhaps after all, the real play has not yet begun…meanwhile the lakes ripple on in the endless mountain breeze; the waterfalls roar in the canyons; the purple mountains glow in the sunrise. The picturesqueness of the little lost city is not desecrated—not yet.*[330]

NOTES

Chapter 1

1. "For Clark's Fork," *Bozeman Avant Courier*, April 18, 1873.
2. *New North-West* (Deer Lodge, MT), September 13, 1873.
3. *New North-West* (Deer Lodge, MT), April 7, 1871.
4. "The Clark's Fork Mines," *New North-West* (Deer Lodge, MT), April 14, 1871.
5. *New North-West* (Deer Lodge, MT), June 24, 1871.
6. "A New *Enterprise*," *New North-West* (Deer Lodge, MT), January 28, 1876.
7. Gay Randall, 94.
8. Plassmann, M.E., "James Gourley, Montana Pioneer of 1862, Saw Exciting Times Along the Yellowstone," *Choteau Acantha*, October 6, 1927.
9. Henderson, A.B., "Narrative of Prospecting Expedition to the East Fork and Clarks Fork of Yellowstone…1870," National Park Service, Yellowstone National Park Library, Vertical Files.
10. Plassmann, "James Gourley."
11. Henderson, "Narrative of Prospecting Expedition."
12. Plassmann, "James Gourley."
13. Henderson, "Narrative of Prospecting Expedition."
14. Norris, P.W., "Report Upon the Yellowstone National Park to the Secretary of the Interior," 1877, 841.
15. Goss, 38.
16. *Benton Record*, September 7, 1877.

17. *New North-West* (Deer Lodge, MT), September 14, 1877.

18. *Rocky Mountain Husbandman* (Diamond City, MT), June 13, 1878.

19. *Choteau Acantha*, January 16, 1936.

Chapter 2

20. Haines, Aubrey L., *The Yellowstone Story: A History of Our First National Park. Vol. 1* (Yellowstone National Park, WY: Yellowstone Association for Natural Science, History and Education, 1996), 105.

21. Lubetkin, M. John, *Jay Cooke's Gamble: The Northern Pacific Railroad, the Sioux, and the Panic of 1873* (Norman: University of Oklahoma Press, 2014).

22. *Helena Weekly Herald*, March 4, 1880.

23. *Bozeman Avant Courier*, June 24, 1880.

24. Eltonhead, Mrs. Edward, *Montana as a Territory—1880–81*, Montana Historical Society, 1919, 4.

25. *Bozeman Avant Courier*, July 1, 1880.

26. Ibid.

27. Eltonhead, *Montana as a Territory*, 31.

28. *Bozeman Avant Courier*, July 1, 1880.

29. Ibid.

30. *New North-West* (Deer Lodge, MT), July 16, 1880.

31. Eltonhead, *Montana as a Territory*, 31.

32. Ibid.

33. *Helena Weekly Herald*, July 29, 1880.

34. *Bozeman Avant Courier*, August 5, 1880.

35. "Prospecting Silver Leads on Clark's Fork," *Helena Weekly Herald*, September 9, 1880.

36. Eltonhead, *Montana as a Territory*, 33.

37. Ibid.

38. "Prospecting Silver Leads on Clark's Fork," *Helena Weekly Herald*, September 9, 1880.

39. Eltonhead, *Montana as a Territory*, 35.

Chapter 3

40. "Shrewd Mr. Smythe," *Bozeman Courier* reprint, *River Press* (Fort Benton, MT), December 27, 1882.

41. *Bozeman Courier* reprint, *Helena Weekly Herald*, June 8, 1882.
42. *New North-West* (Deer Lodge, MT), August 4, 1882.
43. *New North-West* (Deer Lodge, MT), January 6, 1882.
44. "Curtailing Reservations," *Helena Weekly Herald*, April 13, 1882.
45. *Benton Weekly Record*, April 20, 1882.
46. *Bozeman Courier* reprint, *River Press* (Fort Benton, MT), April 26, 1882.
47. *New North-West* (Deer Lodge, MT), March 17, 1882.
48. *Helena Weekly Herald*, April 27, 1882.
49. *Carbon County News* (Red Lodge, MT), July 4, 1934.
50. Ibid.
51. "Clarks Fork," *Billings Herald* reprint, *Cheyenne Weekly Leader* (Cheyenne, WY), April 5, 1883.
52. *New North-West* (Deer Lodge, MT), May 11, 1883.
53. *River Press* (Fort Benton, MT), July 11, 1883.
54. "Clarke's Fork Mines," *Montana, Its Climate, Industries and Resources*, 1885.
55. *Livingston Enterprise*, November 21, 1885.
56. *Daily Yellowstone Journal* (Miles City, MT), January 15, 1886.
57. *Livingston Enterprise*, October 24, 1885.
58. *Livingston Enterprise*, December 26, 1885.
59. *Livingston Enterprise*, February 6, 1886.
60. *Livingston Enterprise*, March 13, 1886.
61. *River Press* (Fort Benton, MT), November 7, 1883.
62. *River Press* (Fort Benton, MT), November 21, 1883.
63. Anonymous, *The Montana Blue Book: A Biographical, Historical and Statistical Book of Reference* (Helena, MT: Journal Publishing Co., 1891).
64. *River Press* (Fort Benton, MT), April 30, 1884.
65. *Mineral Argus* (Maiden, MT), March 6, 1884.
66. *New North-West* (Deer Lodge, MT), March 28, 1884.
67. *River Press* (Fort Benton, MT), June 25, 1884.
68. *River Press* (Fort Benton, MT), February 13, 1884.
69. *Daily Cooke Picnic* reprint, *Big Timber Pioneer*, January 2, 1930.
70. *Big Timber Pioneer*, June 17, 1937.
71. *River Press* (Fort Benton, MT), December 12, 1883.
72. "A Cooke City Cuss," *Bozeman Avant Courier*, January 24, 1884.
73. "A Big Game of Crib," *River Press* (Fort Benton, MT), September 2, 1885.
74. *Daily Yellowstone Journal* (Miles City, MT), September 25, 1885.
75. *Big Timber Pioneer*, June 23, 1937.
76. *Livingston Enterprise*, June 12, 1886.
77. *Livingston Enterprise*, July 10, 1886.

78. *Billings Gazette* reprint, *Daily Yellowstone Journal* (Miles City, MT), March 27, 1887.
79. Ibid.
80. *River Press* (Fort Benton, MT), November 28, 1883.
81. "Badly Frozen," *New North-West* (Deer Lodge, MT), April 4, 1884.
82. *Rocky Mountain Husbandman* (Diamond City, MT), March 27, 1884.
83. *Livingston Enterprise*, March 31, 1888.
84. *Livingston Enterprise*, January 15, 1887.

Chapter 4

85. "It Looks Like a Steal," *Great Falls Tribune*, November 7, 1885.
86. *Livingston Enterprise*, December 6, 1884.
87. *Livingston Enterprise*, October 17, 1885.
88. *Journal* reprint, *New North-West* (Deer Lodge, MT), January 21, 1887.
89. *Livingston Enterprise*, January 28, 1888.
90. *Philipsburg Mail*, February 16, 1888.
91. *Philipsburg Mail*, February 23, 1888.
92. Ibid.
93. *Philipsburg Mail*, March 1, 1888.
94. *River Press* (Fort Benton, MT), April 11, 1888.
95. *Livingston Enterprise*, March 24, 1888.
96. *Livingston Enterprise*, May 5, 1888.
97. *Livingston Enterprise*, May 26, 1888.
98. *Livingston Enterprise*, April 6, 1889.
99. *Livingston Enterprise*, August 31, 1889.
100. *Livingston Enterprise*, June 29, 1889.
101. *Livingston Enterprise*, July 6, 1889.
102. *Livingston Enterprise*, June 23, 1888.
103. *Bozeman Chronicle* reprint, *Philipsburg Mail*, March 8, 1888.
104. *Livingston Enterprise*, June 9, 1888.
105. *Livingston Enterprise*, April 20, 1889.
106. *Anaconda Standard*, January 8, 1896.
107. *Big Timber Pioneer*, January 25, 1923.
108. *Great Falls Leader*, January 27, 1889.
109. *Miles City Journal* reprint, *Helena Independent*, January 20, 1889.
110. *Livingston Enterprise*, March 9, 1889.
111. *Livingston Enterprise*, March 2, 1889.

112. *Livingston Enterprise*, March 9, 1889.

113. *Philipsburg Mail*, May 2, 1889.

114. *Livingston Enterprise*, October 12, 1889.

115. Swallow, G.C., "The Cooke City Mines," *Helena Independent*, October 29, 1889.

116. Ibid.

117. Ibid.

118. Ibid.

119. Swallow, G.C., *Helena Independent*, November 8, 1889.

120. Swallow, G.C., *Helena Independent*, November 17, 1889.

121. Swallow, G.C., *Livingston Enterprise*, December 25, 1889.

122. *Red Lodge Picket*, April 12, 1890.

123. *Livingston Enterprise*, April 19, 1890.

124. *Livingston Enterprise*, May 17, 1890.

125. *Helena Independent*, May 4, 1890.

126. "A Millionaire Cooking," *Red Lodge Picket*, June 14, 1890.

127. "Cooke City Gleanings," *Livingston Enterprise*, July 19, 1890.

128. "Cooke City Gleanings," *Livingston Enterprise*, August 2, 1890.

129. "To Change Park Boundaries," *Livingston Enterprise*, February 8, 1890.

130. *Livingston Enterprise*, February 15, 1890.

131. "A Molehill in Labor," *Livingston Enterprise*, March 22, 1890.

132. *Livingston Enterprise*, February 22, 1890.

133. *Livingston Enterprise*, March 8, 1890.

134. *Livingston Enterprise*, February 22, 1890.

135. *Red Lodge Picket*, March 8, 1890.

136. *Livingston Enterprise*, March 15, 1890.

137. *Livingston Enterprise*, April 19, 1890.

138. "Washington Special," *Livingston Enterprise*, April 19, 1890.

139. *Livingston Enterprise*, May 10, 1890.

140. *Helena Independent*, May 19, 1890.

141. *Livingston Enterprise*, March 29, 1890.

142. Ibid.

143. *Livingston Enterprise*, April 12, 1890.

144. *Livingston Enterprise*, August 23, 1890.

145. *Livingston Enterprise*, January 23, 1892.

146. *Livingston Enterprise*, March 19, 1892.

147. *Livingston Enterprise*, May 24, 1890.

148. *Livingston Enterprise*, May 10, 1890.

Chapter 5

149. *New North-West* (Deer Lodge, MT), October 6, 1882.

150. *River Press* (Fort Benton, MT), November 22, 1882.

151. "Cooke City Chat," *Anaconda Standard*, August 31, 1894.

152. "From Cooke City," *Anaconda Standard*, September 3, 1894.

153. "Suicides as Wealth Comes," *Saco Independent*, July 14, 1916.

154. "Fisher, George T.," Pension Files, 1934.

155. Petition for Pension, 1908.

156. *Livingston Enterprise*, December 25, 1889.

157. Prospector, "Cooke City's Mines," *Livingston Enterprise*, December 27, 1890.

158. "Cooke City Chat," *Anaconda Standard*, August 31, 1894.

159. "Dead and Alone," *Anaconda Standard*, September 8, 1895.

160. "Gnawed His Way to Liberty," *Big Timber Pioneer*, February 11, 1897.

161. Ibid.

162. "Martin Ranmael Tells Story of Early Cooke City History," *Big Timber Pioneer*, April 5, 1928.

163. "An Elopement," *Livingston Enterprise*, January 24, 1885.

164. *River Press* (Fort Benton, MT), February 4, 1885.

165. "Fatal Shooting of Neil Lane," *Daily Yellowstone Journal* (Miles City, MT), April 28, 1885.

166. *Daily Yellowstone Journal* (Miles City, MT), April 29, 1885.

167. "Johnson, the Homicide, Discharged," *Bozeman Courier* reprint, *New North-West* (Deer Lodge, MT), May 29, 1885.

168. "Shooting Affray at Cooke," *Livingston Enterprise*, September 24, 1892.

169. "Murder at Cooke City," *Anaconda Standard*, September 26, 1892.

170. "Shooting Affray at Cooke," *Livingston Enterprise*, September 24, 1892.

171. "Court at Livingston," *Helena Independent*, November 15, 1892.

172. "Malloy is a Free Man," *Anaconda Standard*, January 11, 1893.

Chapter 6

173. *Great Falls Tribune*, July 31, 1889.

174. *Livingston Enterprise*, August 24, 1889.

175. *Livingston Enterprise*, October 19, 1889.

176. *Livingston Enterprise*, August 3, 1889.

177. *Helena Independent*, August 8, 1889.

178. "A Big Mining Deal," *Livingston Enterprise*, June 8, 1889.
179. *Livingston Enterprise*, September 21, 1889.
180. *Livingston Enterprise*, August 13, 1887.
181. *Livingston Enterprise*, September 21, 1889.
182. "Republican Rally at Cooke," *Livingston Enterprise*, September 21, 1889.
183. *Livingston Enterprise*, November 9, 1889.
184. *Livingston Enterprise*, January 11, 1890.
185. *Livingston Enterprise*, February 15, 1890.
186. Ibid.
187. *Livingston Enterprise*, February 22, 1890.
188. *Livingston Enterprise*, March 1, 1890.
189. *Livingston Enterprise*, February 13, 1892.
190. "St. Patrick's Day at Cooke," *Livingston Enterprise*, March 26, 1892.
191. *Livingston Enterprise*, May 21, 1892.
192. *Red Lodge Picket*, May 28, 1892.
193. "Cooke City Notes," *Livingston Enterprise*, October 29, 1892.
194. "Cooke City Chatter," *Anaconda Standard*, April 9, 1893.
195. Ibid.
196. "From Cooke City," *Anaconda Standard*, July 8, 1893.
197. *Red Lodge Picket*, June 24, 1893.
198. "From Cooke City," *Anaconda Standard*, July 8, 1893.
199. "Cooke City Cracks," *Anaconda Standard*, April 19, 1893.
200. "New Telephone Line," *Helena Independent*, April 27, 1893.
201. "At Cooke City," *Anaconda Standard*, May 22, 1893.
202. "In Cooke City," *Anaconda Standard*, October 23, 1893.
203. "From Cooke City," *Anaconda Standard*, November 20, 1893.
204. "In Cooke City," *Anaconda Standard*, February 5, 1894.
205. "From Cooke City," *Anaconda Standard*, June 11, 1894.
206. "In Cooke City," *Anaconda Standard*, February 5, 1894.
207. "Cooke City Chat," *Anaconda Standard*, April 3, 1894.
208. "Cooke City Chat," *Anaconda Standard*, April 23, 1894.
209. Ibid.
210. "From Cooke City," *Anaconda Standard*, June 11, 1894.

Chapter 7

211. "Protest and Petition," *Livingston Enterprise*, January 2, 1892.
212. *Livingston Enterprise*, January 30, 1892.

213. "Cooke City and the World's Fair," *Livingston Enterprise*, January 23, 1892.
214. *Livingston Enterprise*, February 13, 1892.
215. "Patiently Waiting," *Anaconda Standard*, June 11, 1892.
216. Ibid.
217. "Cooke City Notes," *Anaconda Standard*, June 18, 1892.
218. *Livingston Enterprise*, June 4, 1892.
219. *Livingston Enterprise*, August 20, 1892.
220. *Livingston Enterprise*, July 2, 1892.
221. *Livingston Enterprise*, August 27, 1892.
222. *Livingston Enterprise*, October 8, 1892.
223. *Helena Independent*, September 17, 1892.
224. *Castle Tribune* reprint, *Livingston Enterprise*, December 24, 1892.
225. *Helena Independent*, January 5, 1893.
226. "Cooke City Railroad," *Livingston Enterprise*, February 20, 1892.
227. *Red Lodge Picket*, March 4, 1893. Early in February 1893, Senator Hatch had promoted a plan that would change county boundaries and place Cooke City in Sweetgrass rather than Park County, but the measure never took hold.
228. "A Road to Cooke Assured," *Red Lodge Picket*, May 20, 1893.
229. "Cooke City Circles," *Anaconda Standard*, March 20, 1893.
230. *Big Timber Pioneer*, June 8, 1893.
231. "Well Watered Stock," *Anaconda Standard*, May 11, 1894.
232. "Cooke City Happy," *Anaconda Standard*, November 14, 1895.
233. *Anaconda Standard*, June 26, 1895.
234. "The Cooke City Road," *Anaconda Standard*, November 26, 1895.
235. "Have Courage Cooke," *Red Lodge Picket*, August 10, 1900.
236. "Railroad for Cooke," *Red Lodge Picket*, October 26, 1900.
237. Ibid.
238. "Railroad to Cooke City," *Red Lodge Picket*, January 31, 1901.
239. *Livingston Enterprise* reprint, *Big Timber Pioneer*, February 14, 1901.
240. "Again Disappointed," *Red Lodge Picket*, February 15, 1901.
241. "Cooke City Talk," *Bozeman Chronicle* reprint, *Red Lodge Picket*, October 18, 1901.
242. *Big Timber Pioneer*, December 26, 1901.
243. "Cooke City Mines," *Butte Intermountain*, February 13, 1902.
244. "Railroad to Cooke," *Butte Intermountain*, February 1, 1902.
245. "Great Things for Boulder," *Big Timber Pioneer*, February 27, 1902.
246. *Post* reprint, *Wonderland* (Gardiner, MT), July 17, 1902.
247. "Big Timber to Cooke," *Big Timber Pioneer*, August 21, 1902.

248. "It Would Pay," *Big Timber Pioneer*, August 21, 1902.
249. *Red Lodge Picket*, September 19, 1902.
250. "Survey Completed," *Big Timber Pioneer*, October 16, 1902.
251. "Good Times at Cooke," *Wonderland* (Gardiner, MT), September 25, 1902.

Chapter 8

252. "The Mines of Montana," *Helena Independent*, December 31, 1889.
253. *Livingston Enterprise*, February 7, 1891.
254. "The Cyanide Process," *Livingston Enterprise*, July 30, 1892.
255. *Livingston Enterprise*, August 6, 1892.
256. *Livingston Enterprise*, August 27, 1892.
257. *Livingston Enterprise*, September 17, 1892.
258. *Livingston Enterprise*, October 29, 1892.
259. "The Cyanide Mill Started," *Daily Independent* (Helena, MT), January 26, 1893.
260. "Sixteen Days' Run," *Helena Independent*, March 18, 1893.
261. "The Cyanide Process," *Bozeman Courier* reprint, *New North-West* (Deer Lodge, MT), March 18, 1893.
262. "Sixteen Days' Run," *Helena Independent*, March 18, 1893.
263. Ibid.
264. "Cooke City Cracks," *Anaconda Standard*, April 19, 1893.
265. "In Cooke City," *Anaconda Standard*, October 23, 1893.
266. "Cooke City Chat," *Anaconda Standard*, April 23, 1894.
267. "At Cooke City," *Anaconda Standard*, June 22, 1894.
268. "Cooke City Items," *Anaconda Standard*, March 24, 1894.
269. "From Cooke City," *Anaconda Standard*, June 11, 1894.
270. *Red Lodge Picket*, May 20, 1893.
271. "Miners at Cooke City," *Anaconda Standard*, May 14, 1895.
272. "Harry Gassert Dead," *Anaconda Standard*, February 18, 1896.
273. "Jacob Redding Dead," *Anaconda Standard*, February 9, 1897.
274. *Anaconda Standard*, February 18, 1898.
275. *New North-West* (Deer Lodge, MT), June 26, 1896.
276. "Cooke City Mines," *Anaconda Standard*, December 9, 1896.
277. *Big Timber Pioneer*, August 5, 1897.
278. *Anaconda Standard*, August 13, 1897.
279. "At Cooke City," *Anaconda Standard*, June 12, 1897.
280. "Gnawed His Way to Liberty," *Big Timber Pioneer*, February 11, 1897.

281. *Red Lodge Picket*, September 25, 1897.

282. *Red Lodge Picket*, June 18, 1898.

283. "Matters in Park County," *Anaconda Standard*, October 17, 1899.

284. *Gardiner Wonderland*, November 12, 1904.

285. *Gardiner Wonderland*, November 19, 1904.

286. *Gardiner Wonderland*, December 17, 1904.

287. *Big Timber Pioneer*, July 5, 1906.

288. "Cooke City, of the New World Mining District," History of Park County, *Livingston Enterprise*, January 1, 1900.

289. Lockhart, Caroline, "Aged Prospectors Still Wait in Old Mining Town for Future," *Denver Post*, September 8, 1923.

290. "Anton Zucker," Ancestry.com, New York, Passenger Lists, 1820–1957 (database online) (Provo, UT: Ancestry Operations, Inc., 2010).

291. "Anton Zucker," Ancestry.com, 1900 United States Census (database online) (Provo, UT: Ancestry.com Operations, Inc., 2004).

292. Zerr, Gertrude A., "The People Who Stayed," *Sunset Magazine*, April 22, 1917.

293. Zucker, Anastazie, personal letter, Cooke City Montana Museum, November 16, 1925.

294. Ibid.

295. Elno, "Cooke City, Almost Completely Isolated from Outside World," *Choteau Acantha*, February 1, 1940.

296. "Cooke City Gleanings," *Red Lodge Picket*, August 17, 1900.

297. "Cook's Annual Exodus," *Red Lodge Picket*, September 28, 1900.

298. "Have Courage Cooke," *Red Lodge Picket*, August 10, 1900.

Chapter 9

299. "Cooke City Mines," *Butte Intermountain*, February 13, 1902.

300. "People We Read About," *Red Lodge Picket*, August 8, 1902.

301. "'Pike' Moore Dead," *Butte Intermountain*, March 3, 1903.

302. "Cooke City Deserves Notice," *Gardiner Wonderland*, February 2, 1904.

303. "Cooke Mill is a Go," *Gardiner Wonderland*, February 27, 1904.

304. *Gardiner Wonderland*, November 12, 1904.

305. *Ronan Pioneer*, February 9, 1917.

306. "Cooke City, Called Riches Montana Mining Camp, To Come into its Own After Half a Century Through New Railroad," *Choteau Montanan*, May 3, 1918.

307. *Flathead Courier*, January 2, 1919.

308. "Is Cooke City, Ghost Camp of 80's, to Become Great Mining Metropolis Soon?" *Flathead Courier*, February 12, 1920.

309. "Cooke City Highway Is All Arranged," *Big Timber Pioneer*, April 22, 1920.

310. "Four Million Sale of Cooke Property," *Big Timber Pioneer*, May 6, 1920.

311. "New Road to Cooke City Will Make Historic Old Camp Mining Metropolis," *Choteau Montanan*, November 26, 1920.

312. "Auto Successfully Driven from Cooke," *Northern Wyoming Herald*, September 24, 1919.

313. "Cooke City, Aged Mining Camp on Edge of Yellowstone Park, Looks for Boom," *Choteau Montanan*, October 21, 1921.

314. "Work on Cooke City Road to Begin Right Away," *Fallon County Times* (Baker, MT), October 12, 1922.

315. *Cody Enterprise*, August 22, 1923.

Chapter 10

316. "Cooke City Mining Camp Visited by Party from Cody," *Cody Enterprise*, August 10, 1927.

317. *Big Timber Pioneer*, August 2, 1928.

318. "Five Thousand Attend Cooke City Fish Fry," *Big Timber Pioneer*, August 7, 1941.

319. "Cody Writer Marks Last Resting Place of Pioneer Miners," *Cody Enterprise*, August 17, 1927.

320. "James Gourley, Montana Pioneer of 1852, Saw Exciting Times Along the Yellowstone," *Choteau Acantha*, October 6, 1927.

321. "People Are Still Searching for 'Golden Boot' Thought to Be Hidden in Cooke City Region," *Choteau Acantha*, November 29, 1934.

322. "Cooke City Road Beckons Public," *Big Timber Pioneer*, July 30, 1936.

323. "New Town Born in Park County," *Choteau Acantha*, February 4, 1932.

324. "A.G. Vincelette Opens and Operates Silver Gate Camp," *Fallon County Times* (Baker, MT), June 29, 1933.

325. "Silver Gate Is Heaven of Fishermen and Vacationists State the Local People Who Camped There," *Fallon County Times* (Baker, MT), August 16, 1934.

326. "German Magazine to Show Montana Areas," *Big Timber Pioneer*, September 19, 1935.

327. "Back to Silver Gate," *Big Timber Pioneer*, April 11, 1940.

328. "Silver Gate Inn Burned," *Big Timber Pioneer*, September 3, 1942.

329. "Scenic Highway Opens Picturesque Vacation Land as Cooke City Takes New Lease on Life," *Choteau Acantha*, July 9, 1936.

330. Zerr, "The People Who Stayed."

INDEX

R

Ranmael, Martin 73, 112
Republic Mining Company 43, 47, 48, 82
Robbins, Tom 73
Rocky Fork & Cooke City Railroad Company 53, 55, 92

S

Siegfreidt, Dr. J.O. 113
Silver Gate 88, 122
Swallow, G.C. 58, 61

T

Tanzer, Dr. G.L. 103, 105, 111, 113
Taylor, John L. 122
Tredennick, Nick 48, 81, 111

V

VanDyke, Edward E. 85
Vincelette, A.G. 122
Vinnedge, Alvin P. 69, 82, 85, 89, 91

W

Wells Mining Company 40

Y

Yellowstone National Park 21, 25, 26, 50, 59, 68, 92, 99, 122
Yellowstone Park Railroad Company 94

Z

Zerr, Gertrude 107, 109
Zucker, Anastazie 5, 10, 107
Zucker, Anton 106, 107